CRAFT-A-DOODLE

CRAFT-A-DOODLE

75 Creative Exercises from 18 Artists

JENNY DOH

LARK CRAFTS
Asheville

LARK CRAFTS

An Imprint of Sterling Publishing
387 Park Avenue South
New York, NY 10016

ISBN 978-1-4547-0422-5

Doh, Jenny.
 Craft-a-Doodle / Jenny Doh. -- 1st ed.
 p. cm.
 Includes bibliographical references and index.
 ISBN 978-1-4547-0422-5
 1. Drawing. I. Title.
 TT867.D64 2013
 761--dc23

 2012030626

Distributed in Canada by Sterling Publishing
c/o Canadian Manda Group, 165 Dufferin Street
Toronto, Ontario, Canada M6K 3H6
Distributed in the United Kingdom by GMC Distribution Services
Castle Place, 166 High Street, Lewes, East Sussex, England BN7 1XU
Distributed in Australia by Capricorn Link (Australia) Pty. Ltd.
P.O. Box 704, Windsor, NSW 2756, Australia

For information about custom editions, special sales, and premium and corporate purchases,
please contact Sterling Special Sales at 800-805-5489 or specialsales@sterlingpublishing.com.

Email academic@larkbooks.com for information about desk and examination copies.
The complete policy can be found at larkcrafts.com.

Every effort has been made to ensure that all the information in this book is accurate. However, due to differing
conditions, tools, and individual skills, the publisher cannot be responsible for any injuries, losses, and other
damages that may result from the use of the information in this book.

Manufactured in China

2 4 6 8 10 9 7 5 3 1

larkcrafts.com

CONTENTS

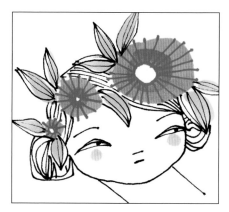

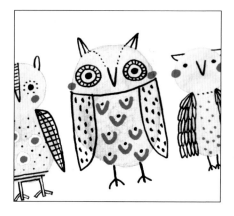

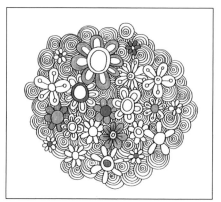

INTRODUCTION

by Jenny Doh

The act of making a doodle is not complicated. It's about picking up a pen or pencil and making a dot, a line, a squiggle, or any other shape onto a piece of paper. It's fun and simple.

The great thing about doodling is that one mark usually leads to another mark, and then another one and then another. Collectively, the doodled marks lead to the creation of a finished work that can either look very literal, such as the delightful doodled faces by **Cori Dantini** (page 8), or the adorable pugs by **Gemma Correll** (page 18). The finished works can look splendidly abstract, such as the doodled ripples by **Stephanie Kubo** (page 88), or the awesomely unconventional character by **Carla Sonheim** (page 26).

Doodling has reached new heights of popularity among people of all ages, backgrounds, and creative interests. There are no solvents to mix, no sealants to spray, and no glue gun to heat. It's truly a ready-set-go activity that ignites creativity in people who are willing to pick up a pen and give it a try. In *Craft-a-Doodle*, 18 talented doodlers offer 75 prompts and exercises designed to help readers experience the joy of doodling. These contributors are: **Hanna Andersson, Julie Armbruster, Flora Chang, Gemma Correll, Cori Dantini, Corinne Dean, Pamela Keravuori, Stephanie Kubo, Mafalda Laezza, Teresa McFayden, Dinara Mirtalipova, Jessie Oleson Moore, Teesha Moore, Aimee Ray, Cynthia Shaffer, Dawn DeVries Sokol, Carla Sonheim,** and **Jennifer Taylor**. With their guidance, you will learn how to doodle in many unexpected ways. For example, you'll doodle with milk, you'll doodle on rocks, you'll doodle based on ink splatters, you'll doodle a big cat hugging a little kitty, you'll turn your doodles into works of embroidery, and so much more.

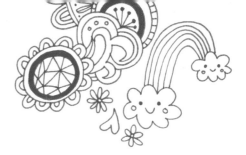

HOW TO USE THIS BOOK

You'll find that many of the prompts in this book can be created with just paper and a pen or markers, so gather your favorite writing instruments and either a blank journal or a stack of plain white paper, and you'll be ready to begin. Many of the doodles feature colorful brush-tip markers, watercolors, colored pencils, ink, gel pens, and other appealing materials. Perhaps you have an array of these drawing tools already at hand, or maybe you'll be inspired to expand your artistic supplies to try a new technique.

Some prompts are slightly lengthier than others, with more detailed lists of tools and materials and accompanying step-by-step photography. For example, a few will ask you to gather tissue paper, cardstock, yarn, or black scratch panels. Even with these unique items, however, the amount of preparation is streamlined so you can jump right in. There's no need to methodically work through the book in order—begin with whatever prompt catches your attention and enjoy the process of crafting doodles as your intuition desires.

All of the book's exercises are designed to infuse your creativity with playfulness and exploration. Have fun experimenting and using these projects as a springboard for your own inventive drawings. You'll find that you can start and finish most of these exercises wherever you find yourself—in the studio, in the kitchen, on the sofa, or even on the bus.

The most important thing to remember about doodling and completing the exercises in this book is to allow your imagination to blossom and take center stage. Even though the contributors share the specifics of how they doodle, you can put your own artistic twist into what they share to make each doodle uniquely your very own.

Are you ready to doodle?
Craft-a-Doodle is ready for you.

designer: CORI DANTINI

Recipe for a FACE

DOODLE PROMPT: This exercise is similar to a recipe—it has all the ingredients needed to put a face together, but it's up to you to cook up a face you love. The sky's the limit here, so have fun and make lots of expressive, weird, pretty, silly faces!

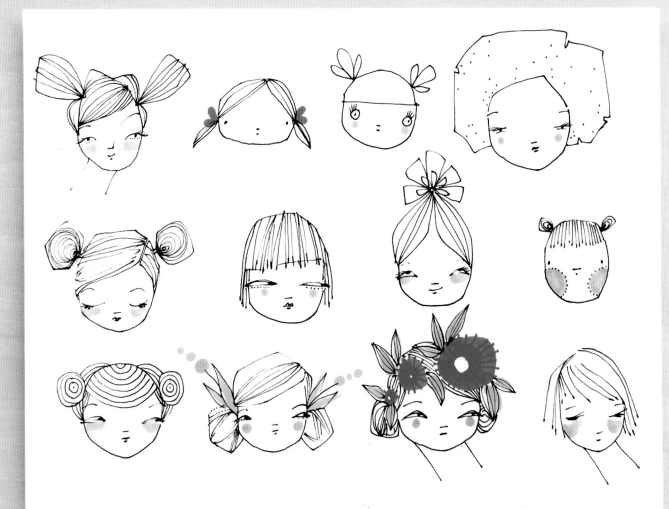

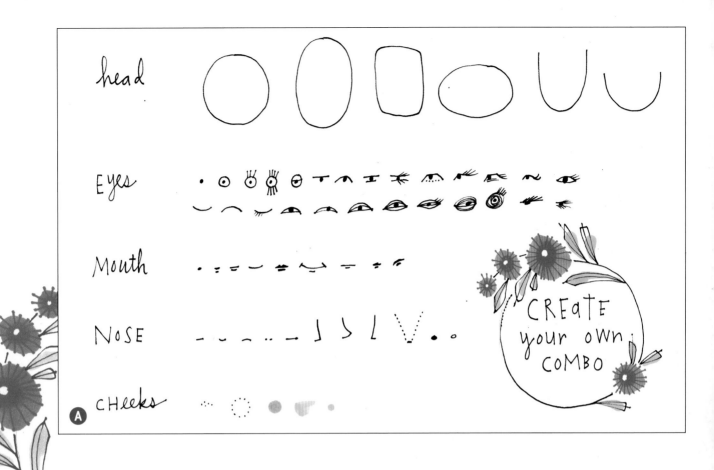

head

Eyes

Mouth

Nose

CREATE
your own
COMBO

CHeeks

A

what you'll need

- White paper
- Black fine-point marker (.005)
- Pencil (optional)
- Eraser (optional)
- Markers in assorted colors

instructions

1 Select a shape from the recipe of heads and draw it onto your paper with a black fine-point marker. **A** **B**
 Note: If you are feeling cautious, make the face doodle first in pencil and then trace over the pencil marks with a black marker. Once the ink is dry, erase the pencil marks. If you're not feeling as cautious, grab a black marker and begin.

2 Select a shape from the recipe of noses. Remember that the nose generally sits between where you put your eyes and the bottom of the chin. With that in mind, draw the nose shape inside the head shape, somewhere that makes you happy. **C**

B

C

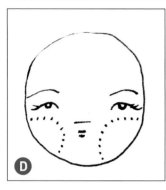

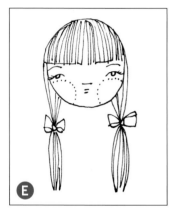

D

E

3 Select a set of eyes from the recipe of eyes and draw them on either side of the nose. Place them far apart or close together.

4 Select a mouth shape from the recipe of mouths and draw it below the nose. The mouth, of course, sits between the nose and the chin, but where you draw it is completely up to you. Then add cheeks. Ⓓ

5 Select from the various hair options and draw hair around the face. Have fun with this part. Maybe it's a bun or pigtails—or maybe you want to draw a big flower instead of hair! Ⓔ

6 Add touches of color on the cheeks and hair with colored markers.

GENERAL GUIDELINES (feel free to BREAK the RULES!)

1. Eyes go IN the MIDDLE of the face.

2. Nose goes IN the MIDDLE of Eyes + chin.

3. Mouth goes IN THE MIDDLE of Nose + chin

F

breaking the rules

Above are general guidelines I use when drawing a face. In this and any other doodle prompt, I encourage you to learn to follow the rules, then dare to break them and see what happens, as you find your own unique doodling voice. Ⓕ

MR. OWL

DOODLE PROMPT: Follow these steps to doodle a bright-eyed little owl.

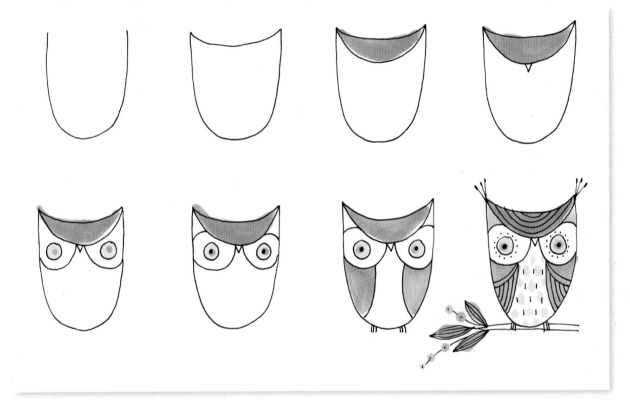

>>> **try it**

Draw the body by doodling a big U with a magic marker. Add a very shallow curved line that connects the top points of the U. Add another curved line below the first and color it in with a light orange brush-tip marker. Add a small V for the beak.

For the face, doodle two curved lines to contain the owl's eyes, running from each side of the face to the side of the beak. Then draw circles for the eyes and color them in with a light yellow marker. Add smaller circles to the center of each eye with the deep-yellow marker. Add black dots for pupils and draw little dotted circles to complete the eyes.

To finish the body, add small marks for the owl's feet. Add two slightly curved lines to act as wings and color them with the deep yellow marker.

Add fun details like leaves, flowers, and patterns for the owl's chest and wings. Ask yourself where the owl lives and put him there.

A BLOSSOM

DOODLE PROMPT: Try these steps for doodling a
single starburst blossom.

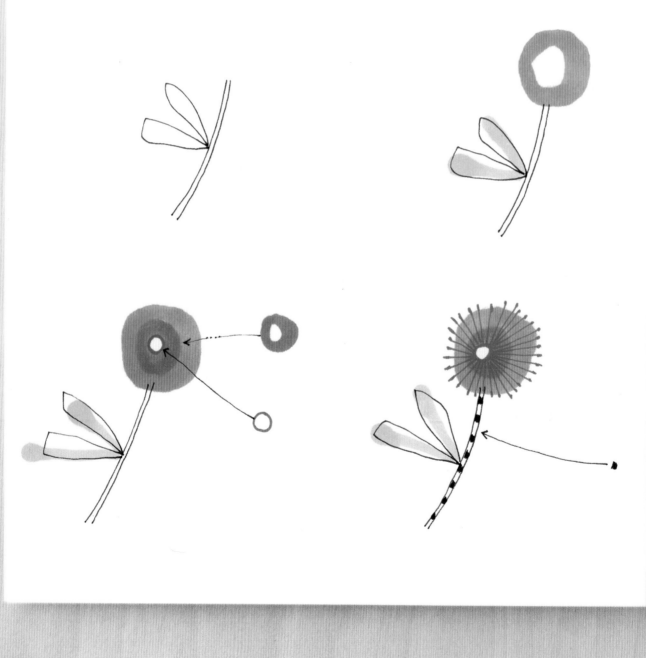

what you'll need

- White paper
- Black extra-fine-point marker
- Dark pink brush-tip marker
- Light green brush-tip marker
- Deep red brush-tip marker
- Red extra-fine-point marker

instructions

1 Use a black extra-fine-point marker to doodle two lines at an angle, pretty close together. This will be your flower stem. Add two curved tear drop shapes on the left side of the stem. These will be the flower's leaves.

2 Use a dark pink brush-tip marker to doodle a chunky, organic circle at the top of the stem. Use a light green brush-tip marker to color the leaves. In order to achieve a fuller line, place the tip of the marker in the closed portion of the teardrop and slowly push out to the tip of the leaf while pressing a bit harder as you go.

3 Use a deep red brush-tip marker and doodle a smaller chunky, organic circle within the larger pink circle. Use a red extra-fine-point marker and doodle a small circle at the center of the deep red circle. Continuing with the red marker, doodle multiple lines by starting at the edge of the inner red circle and extending past the pink marker circle. Leave the marker sitting for a long second at the end of each line to create a dot there. Add little black marks throughout the stem.

tip

Change up the colors, add more leaves, and play with scale. Perhaps this small blossom is just the middle of an even larger flower that you doodle!

FLOWER SPRAY

DOODLE PROMPT: Experiment with two ways to doodle a spray of flowers.

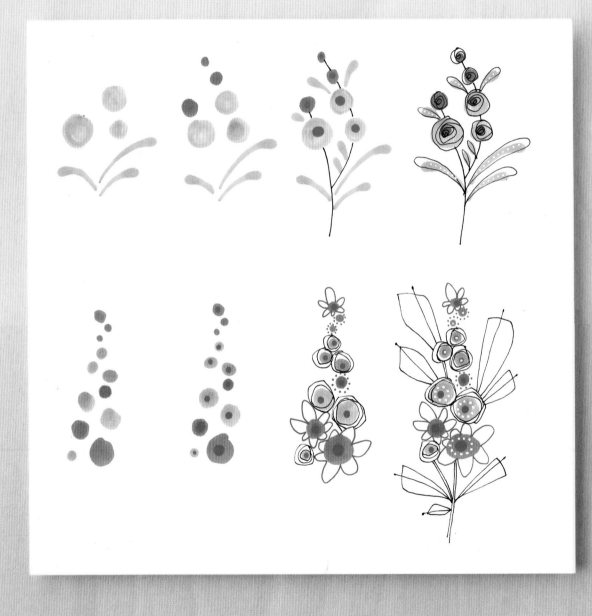

what you'll need

- White paper
- Light pink brush-tip marker
- Light green brush-tip marker
- Dark pink brush-tip marker
- Red brush-tip marker
- Black extra-fine-point marker
- White extra-fine-point poster-paint marker
- Red extra-fine-point marker

instructions

Spray 1

1 Use a light pink brush-tip marker to make three small circles.
2 Use a light green brush-tip marker to make three leaves by lightly putting the tip of the marker on the paper and push/pull it in the direction you want the leaves to go. While making this line, slowly push the marker down harder to create the widening line (or in this case, the end of the leaf).
3 Use a dark pink brush-tip marker to add three small circles.
4 Use a red brush-tip marker to add dots to the centers of each flower.
5 Use a black extra-fine-point marker to add lines for stems that connect the flowers together. Use the light green marker to add more leaves.
6 Use the black marker to add loose swirls over each of the dots and loose petal shapes around each of the leaves.
7 Use a white poster-paint marker to add white dots on some of the leaves.

Spray 2

1 Working from top to bottom, create a series of circles with light pink and dark pink brush-tip markers, making them different sizes.
2 With a red brush-tip marker, add small dots to the centers of each circle to make them into flowers.
3 Use a black extra-fine-point marker to add loose repeating circles around some of the flowers.
4 Use the red extra-fine-point marker to make loose petal shapes and dots around some of the flowers.
5 Use the black marker to add stems and leaves.
6 Use a white poster-paint marker to add dots to some of the flowers, including the red flower centers.

tips

- Use these flower spray doodles in place of trees in larger scenic drawings.
- Add a spray or two to the hair of a doodled face.
- Flower sprays also act as a great landing spot for any small creature.
- White poster-paint markers are water-based and provide good contrast when applied onto colored doodles or directly onto colored paper.

A BLOOM

DOODLE PROMPT: Learn how to doodle a dynamic flower with pointy petals.

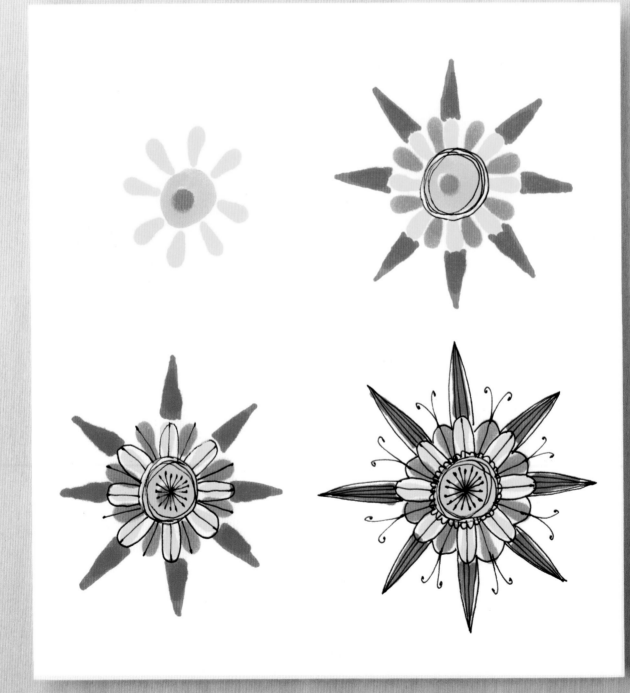

what you'll need

- White paper
- Green brush-tip marker
- Orange brush-tip marker
- Yellow brush-tip marker
- Red brush-tip marker
- Black extra-fine-point marker

instructions

1 Use the green marker to make a circle. Fill in the middle of the circle with an orange marker. Use a yellow marker to make eight teardrop shapes outside the green circle; create these shapes by putting the brush tip down lightly and pushing the pen in the direction you want the teardrop to go.

2 Make eight teardrop shapes with an orange marker, in between the yellow teardrops.

3 At the end of each of the yellow teardrops, use a red marker to add a long triangle shape.

4 Use a black extra-fine-point marker to doodle a loose set of circles around the outer edge of the green circle. Continue using the black marker through the remaining steps.

5 Doodle a starburst at the center of the flower. Add eight horseshoe shapes, one on each of the yellow teardrops. Add straight lines down the center of each of the orange teardrops.

6 Over the top of each red triangle, loosely draw a series of lines that come together at the top. Think of this as drawing the tip of an almond.

7 Add eight curly V-shapes to the outer edge of the orange teardrops. Try and get the point of the V-shapes to line up with the line that is already running down the middle of the flower petal.

8 Add small scallops around the inner green circle.

tip

Remain loose when making the flowers by inviting a little bit of sloppiness into the process. This is what makes the magic.

designer: GEMMA CORRELL

The PUGS We LOVE

DOODLE PROMPT: Pugs are loveable. Pugs are cute.
And best of all, pugs are fun and easy to draw.

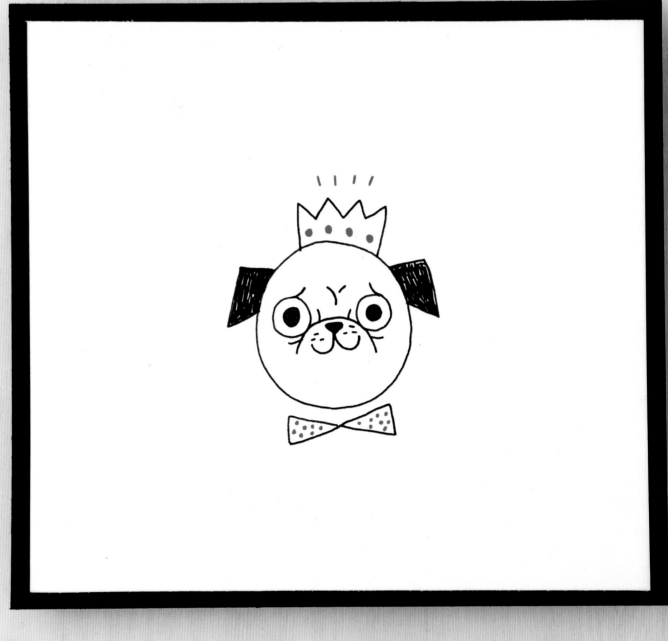

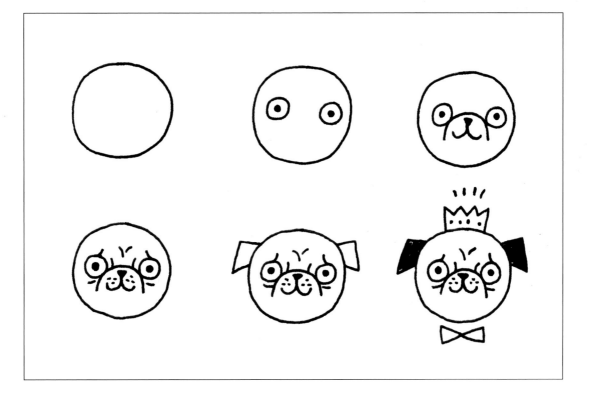

what you'll need

- White cardstock
- Black fine-point marker
- Red fine-point marker

instructions

1 Draw a circle with a black fine-point marker.
2 Draw two small circles for the eyes, with a dot in the center of each circle.
3 For the snout, draw an upside down U that touches both of the eyes. Make a triangle for the nose and two curved lines extending from the small triangle.
4 Doodle facial details with lines near the eyes and forehead. Add small dots in the nose area for whiskers.
5 Draw two partial rectangles on either side of the face for the ears.
6 Fill in the ears with the black marker. Add a crown at the top of the head and a bow right beneath the head.
7 Once you have practiced and gotten the hang of drawing pugs, add red accents on the crown and bow, with a red fine-point marker.

tip

Experiment with doodling facial details that make your pugs display different emotions. Try drawing a happy pug, a worried pug, a sad pug, and a surprised pug.

In PUGS We TRUST

DOODLE PROMPT: Once you know how to draw a pug, draw one on a flag, coupled with a short, sweet, and memorable motto. Just because.

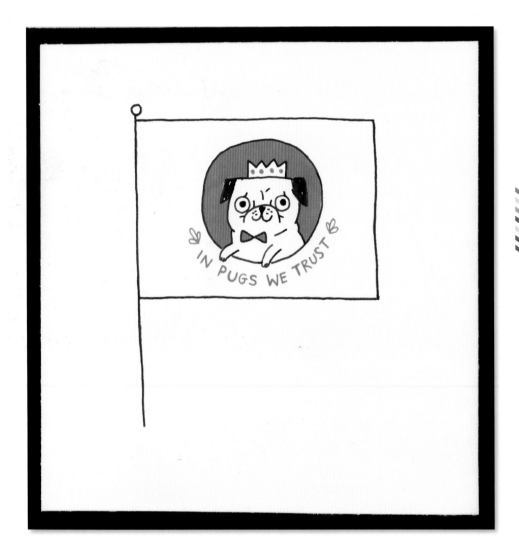

try it

Draw a basic rectangle flag shape with a straight vertical line for the pole, topped with a small circle. Draw a circle (or different shape) inside the flag. Use the methods outlined in The Pugs We Love (page 18) to draw a pug within the circle. You can draw it exactly as taught, or add the pug's upper body and legs. Add details and write your motto with a red fine-point marker. Fill in the background behind the pug with the red marker.

STASH YARN Inspiration

DOODLE PROMPT: Let a scrap piece of yarn or thread guide you in imagining a scene that you doodle.

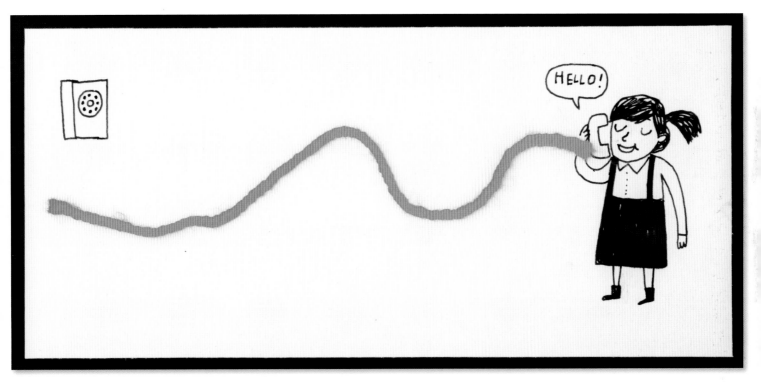

try it

Cut a piece of scrap yarn to a desired length. Place one end of the yarn on top of a gluestick and pull it across to coat the yarn with glue. Let the yarn fall onto a piece of paper and pat it down so that it sticks to the paper. Imagine a scene inspired by the yarn and doodle it. The yarn can be a telephone cord, a noodle, a snake, or anything else you can dream up.

SPLATTER DOODLES

DOODLE PROMPT: Splatter, drip, or flick ink onto paper and see how many unique doodles they can inspire you to make.

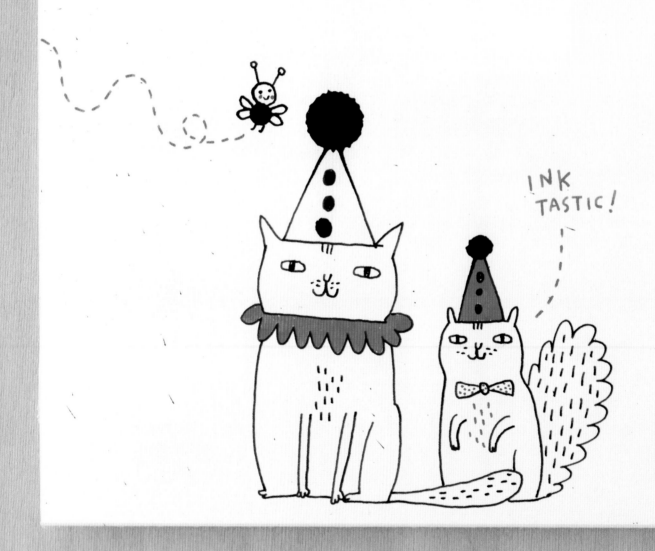

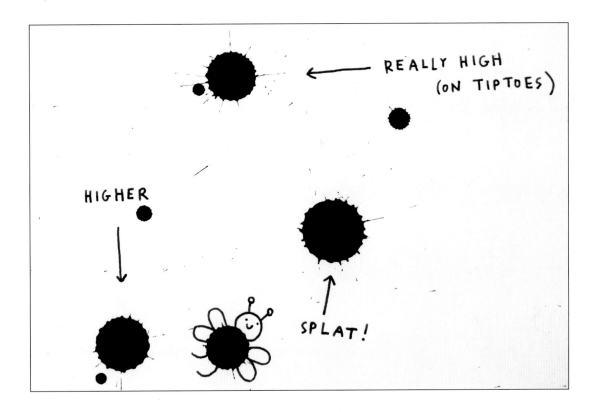

what you'll need

- White cardstock
- Black permanent liquid ink
- Small bowl
- Paintbrush
- Dropper (optional)
- Black fine-point marker
- Red marker
- Red fine-point marker

instructions

1 Place a small amount of black ink into a small bowl.
2 Immerse the paintbrush into the ink until it gets very saturated. Hold the paintbrush above the paper and wait until a drop splatters down onto the paper.

3 Repeat step 2, but try out different ways of dropping the ink. For example, try holding the paintbrush high above the paper, and then holding it very close to the paper. Try tipping the paper after a splatter is made to make it run. Flick the paintbrush to make lots of tiny splatters. If you have a dropper, fill it with ink and see how the drips look different than using a paintbrush.
4 Allow all splatters to dry completely.
5 Look at the splatters and use them to inspire all sorts of drawings and doodles:
- Doodle wings, head, antennae, and legs to turn a splatter into a bee.
- Doodle several pairs of legs to turn a splatter into a spider.

- Draw a triangle below a splatter to make into a party hat.
- Draw a cat's head or the head of any other creature that you like, in a way that makes the creature look like it is wearing the party hat. Stop there, or add a body and other details.
6 Color in parts of your doodle with a red marker. Add dots and dashes with a red fine-point marker.

A VISUAL DIARY

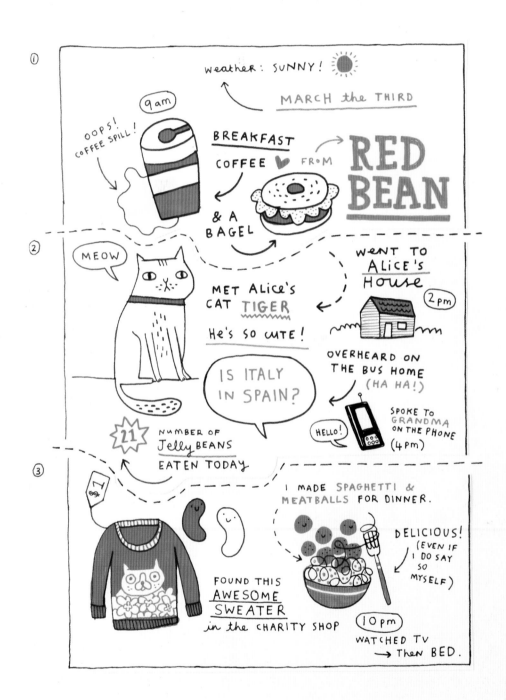

DOODLE PROMPT: Every day is a fresh start. It's like a blank page of paper, waiting to be filled with activities—both planned and unexpected. By dividing the page into thirds (more or less) and doodling the day's events into those thirds, you can keep a very special visual diary.

what you'll need

- White cardstock
- Black fine-point marker
- Red fine-point marker
- Plain white paper

instructions

1 Look at your piece of white cardstock and visualize it divided into thirds—one for the morning, one for the afternoon, and one for the evening. Think of the divisions not as boxes with straight lines but as loose and imperfect sections that allow for curves and bulges.

2 As the day progresses, consider the things you did and pick a few topics to illustrate. Keep the palette simple by using just a black marker and a red marker. The drawings can be about what you ate, what you drank, the weather, friends you visited, people you spoke with on the phone, what you wore, or whatever else you like.

3 Make the drawings simple and add words and short phrases with cute curvy arrows to help explain and tell your story.

4 Leave the page as is or cut the page into actual thirds, and adhere the pieces onto a piece of plain white paper. Doodle dashed lines in between the sections with a black marker.

tip

Time constraints can make it difficult to doodle a visual diary page in the actual moment. Being nervous about messing up the diary page can make it difficult as well. You can opt to map out your plan first, then practice some of your intended drawings and doodles on scratch paper before making the actual diary page. If you do it this way, make sure you don't over-plan. Sometimes, being spontaneous and making some imperfect doodles adds charm to the page.

designer: CARLA SONHEIM

DOODLED SONG

DOODLE PROMPT: My idea for this exercise was to draw something to a single song, so that when I looked at it later, the tune of the song would pop into my head. I began with whatever mindless scribbles, circles, and marks spontaneously happened, which I believe are "true doodles." The song I was listening to is "Kangaroo" by This Mortal Coil.

what you'll need

- White paper
- Black ballpoint pen
- Blue ballpoint pen
- Blue or gray colored pencil

instructions

1 Turn on your selected song and begin doodling with a black ballpoint pen until the song is over. This step is all about not over-thinking things and just having fun making marks. Ⓐ

2 Play the song again and add more doodles or even flesh out an animal or bird with a blue ballpoint pen. This step is when you begin to make conscious choices about what the figure might become. Ⓑ

3 Play the song again as you add color to the doodle with a blue or gray colored pencil. Ⓒ

4 Add other marks with a black ballpoint pen to complete your bird (or whatever you've doodled to your song) until you are satisfied. Ⓓ

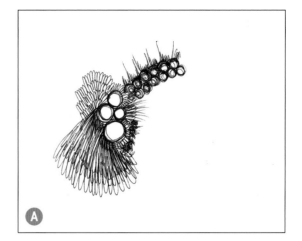

Ⓐ

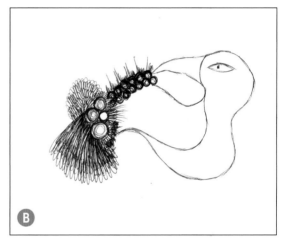

Ⓑ

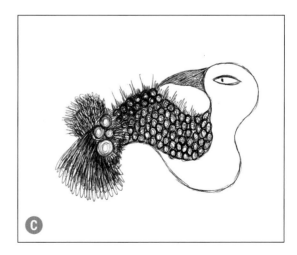

Ⓒ

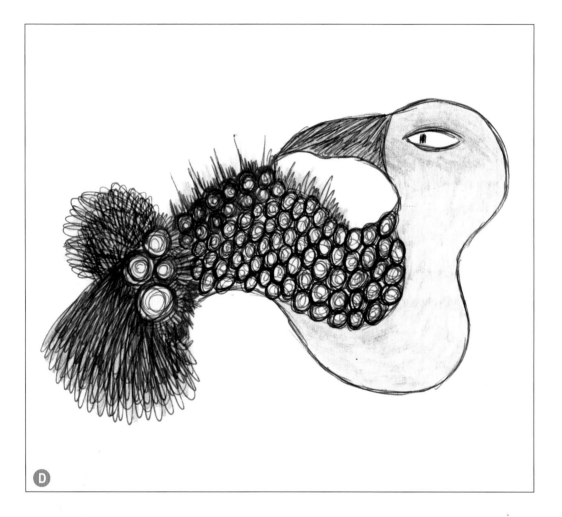

tip

I kept my piece monochromatic, but there's no reason not to add more color if desired. Though I had started this piece with the idea of adding lots of color, I was liking the "blueness" of it after step 3, so I kept it blue. I continually change my mind during the course of a drawing or doodle, and you can too!

CHEATER BLIND MAN

DOODLE PROMPT: Doodling faces from real life is the best. From photos is second best. One non-intimidating way to do it is by using a traditional exercise: a blind contour. This is a modified version of that exercise.

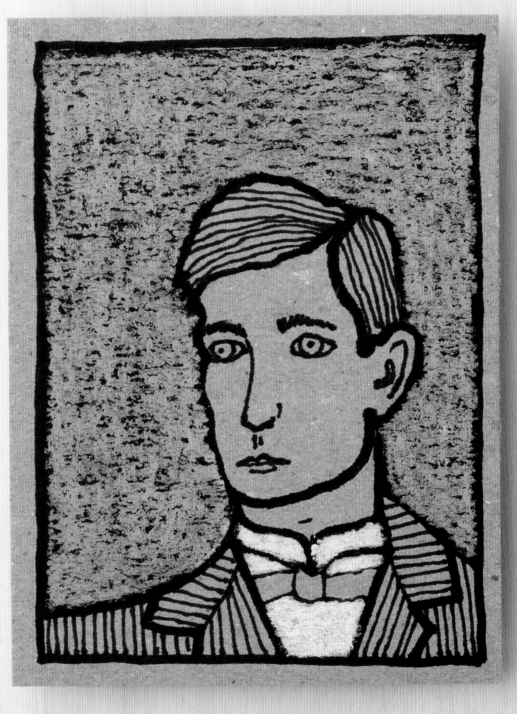

what you'll need

- Chipboard or thin cardboard, cut to 3 x 4 inches (7.6 x 10.2 cm) or other desired size
- Old portrait photograph (either vintage or from your stash of family photos)
- Black fine-point marker
- Black extra-fine-point marker
- Black large, thick marker
- White oil pastel

instructions

1 Draw a frame along the edges of the chipboard with a black fine-point marker. Don't worry about making the lines perfectly straight.

2 Fix your eyes on the edge of your old portrait photo and start drawing with a black fine-point marker. In a true contour drawing, you would draw without looking at the chipboard. For this drawing though, you can "cheat" and look once or twice quickly.

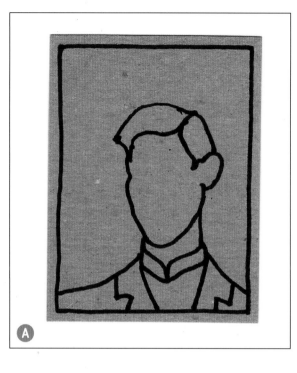

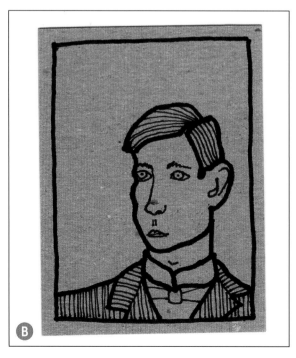

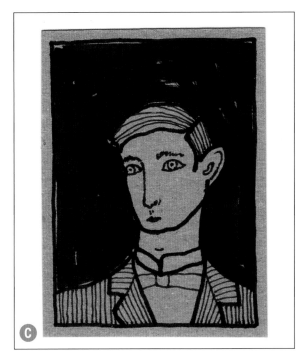

C

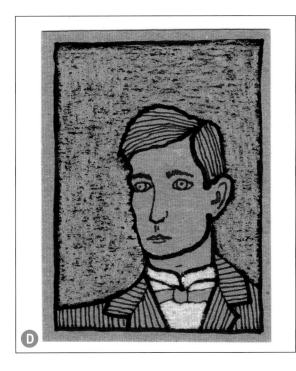

D

3 Continue with your contour drawing, looking a bit more often at your chipboard as you get close to the edges. Ⓐ

4 Grab a black extra-fine point marker and add facial and clothing details, continuing to look at your old portrait photo often. Ⓑ

5 If desired, fill in the background using a large black marker. Ⓒ

6 Draw over the black background with a white oil pastel, which will make it look light blue. Add the white oil pastel to the shirt area. Ⓓ

 tips

- Use any drawing media you wish to use: crayons, pencils, markers, or whatever you like.
- Combine several portraits into one family portrait.

BE SQUARE

DOODLE PROMPT: I admire the work of Saul Steinberg, in particular the way he adds line work and drawings to photographs, ink stamps, collage bits, and so on. In this prompt, I wanted to keep it simple by using square shapes made with a square inkpad and a black marker, then see how many designs I could come up with in a short period of time.

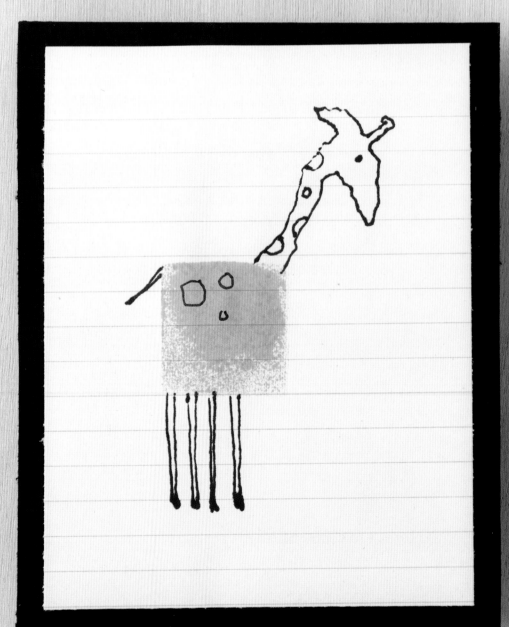

what you'll need

- Dye-based inkpad, 1-inch (2.5 cm) square
- White lined paper (or anything you have on hand)
- Black ultra-fine-point permanent marker

instructions

1 Stamp a small square inkpad directly onto a piece of paper several times. Ⓐ

2 Create assorted doodles related to the stamped squares, working very quickly to "spin off" the image as many ways you can. To doodle the giraffe, make four skinny legs, a tail, some spots on the square, and a long neck with a head. Ⓑ

3 After doodling a dozen or so squares, you might feel that you are running out of ideas. Keep pushing yourself, because sometimes those "tapped out" moments are when the most unique ideas emerge. Ⓒ Ⓓ Ⓔ

Ⓐ

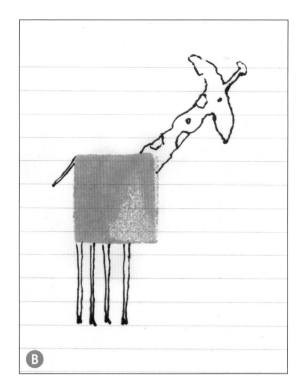

Ⓑ

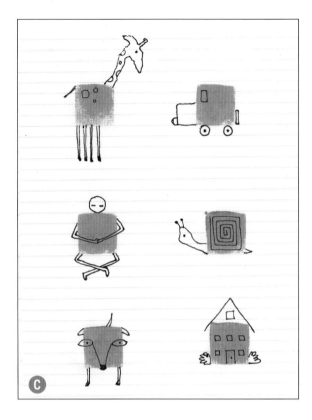

tips

- Using a pen instead of a pencil for the doodling part is important, so you aren't tempted to erase your marks.
- Working fast with a pen will allow you to get many ideas down on paper, to create a library of images to work from later.
- Instead of a square inkpad, try stamping your thumbprint and spinning off from there!

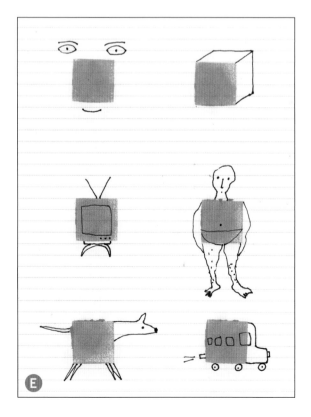

DREAM CATCHER

DOODLE PROMPT: I'm usually a "less is more" kind of person. So with this doodle, I wanted to push myself out of my comfort zone by adding eight layers of doodling to the single Dream Catcher design.

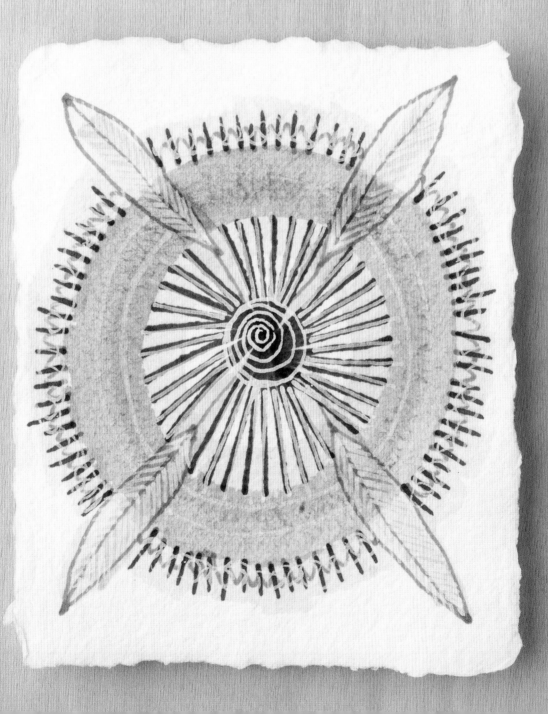

what you'll need

- Heavyweight cold-press watercolor paper, cut or torn to 4 x 5 inches (10.2 x 12.7 cm)
- Wide-tip colored marker (peach, or your preference)
- Watercolors
- Small paintbrush
- Fine-point permanent markers in assorted colors
- White paint pen
- Pencil

instructions

1 Doodle an X with a peach wide-tip marker.
2 With blue watercolor paint and paintbrush, add a blue circle on top. Ⓐ
3 With a gray fine-point marker, draw feather shapes at the ends of the X. Also add lacy, leafy line-work around the perimeter of the circle. Ⓑ
4 With a blue fine-point marker, add some bold lines radiating from the center. Ⓒ

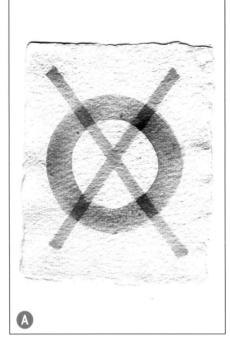

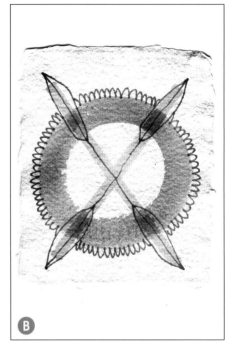

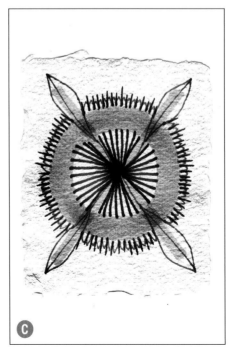

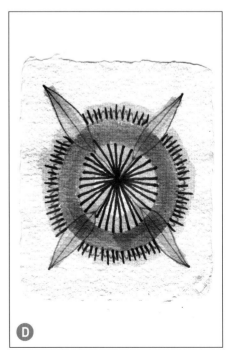

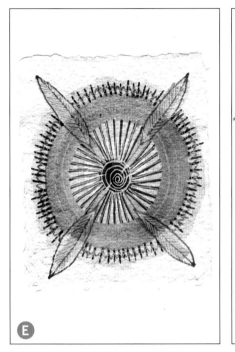

(E)

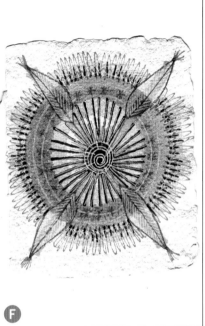

(F)

5 Add yellow watercolor around the outer and inner edges of the circle. **(D)**

6 Use a white paint pen to soften the bold blue lines from step 4, and add subtle details. **(E)**

7 Add accents with a brightly colored permanent marker. (As I was doodling, the piece was starting to look a bit "soft," which I liked. But given that I was trying to push myself out of my comfort zone, I added accents with orange.) **(F)**

8 Add final details with a pencil for added contrast. **(G)**

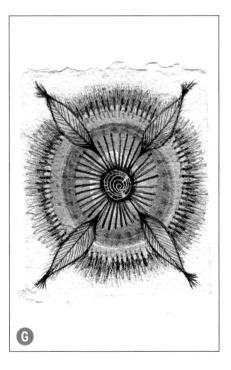

(G)

tip
I used subdued colors in my piece, but there's no reason not to add more color if you like.

designer: FLORA CHANG

LITTLE OWLS

DOODLE PROMPT: Learn how to draw little owls
using diluted black drawing ink, a black brush
tip pen, and a red marker pen.

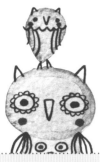

what you'll need

- Watercolor paper
- Black waterproof, permanent calligraphy ink
- Small container for ink
- Small round watercolor brush
- Small jar of clean water
- Watercolor paper
- Black brush-tip pen
- Red extra-fine-point permanent marker

instructions

1 Pour some black calligraphy ink into a small container. Dip the watercolor brush into the black ink, then dip it into a small clean jar of water as if you are cleaning the brush. This will result in a jar of diluted ink water.

2 Saturate the brush with diluted ink water, then make a basic outline shape for the owl: a shape that looks kind of like a snowman. Ⓐ

3 Brush diluted ink water into the outlined shape, continuing until the shape is completely colored in. Allow it to thoroughly dry. Ⓑ

4 Using a black brush-tip marker, doodle simple details such as eyes, beak, ears, wings, and legs on the colored-in shape. Use the red extra-fine-point permanent marker to add cheeks and spot details on the chest. Ⓒ

5 Repeat steps 2 through 4 to create a row of doodled owls. Experiment with a variety of shapes, details, and expressions. Ⓓ

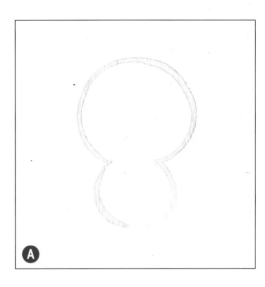

Ⓐ

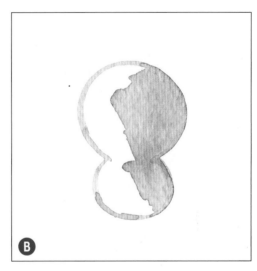

Ⓑ

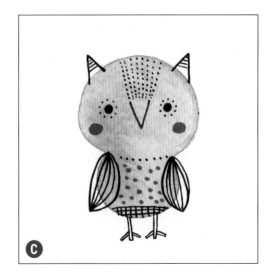

Ⓒ

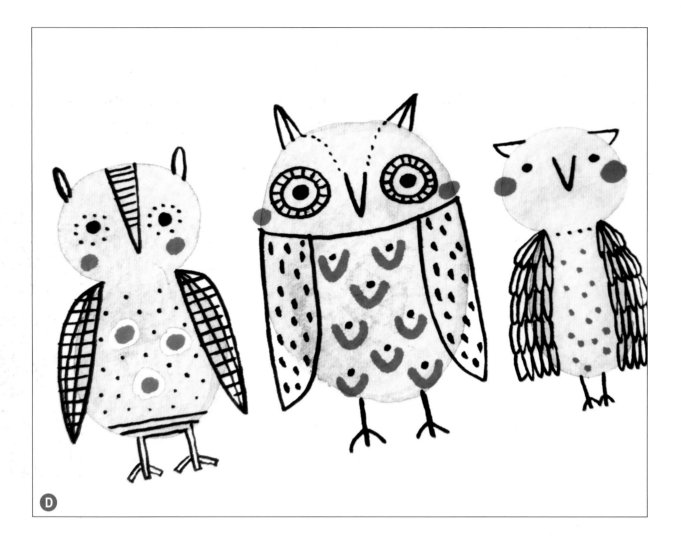

tips

- These owls are fun and fast to draw. You can draw little ones on tags or you can do a very large one on a larger sheet of paper. Add lots of details using the same method.
- It's easier to keep the ink diluted when you start, since you can always add more layers to adjust the darkness. Also make sure the brush is really saturated with the ink water so it glides on top of the paper. The watercolor paper will absorb all the ink water and create a nice effect. The key is not to make a shape with solid even color. You want different shades of gray within the shape.

FAMILY OF CIRCLES

DOODLE PROMPT: Alternating between a brush-tip marker and a fine-point marker, create interesting organic gem-like doodles. Leave the doodles black-and-white or add a bold red background to make them pop.

 try it

Doodle circles and ovals in assorted sizes on your paper. Draw some circles with thicker brush outlines, and others with thinner outlines. Do this until the entire paper is filled. Keep the quality of the line work organic and imperfect.

Add doodled details within each circle, still alternating between the brush-tip and fine-point markers. When you have filled the circles, leave the doodled piece as it is, in black and white, or add color to the background.

SWEET LITTLE Portraits

DOODLE PROMPT: Play with positive and negative space to doodle portraits (and other playful characters), using two colors.

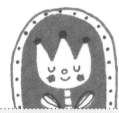

what you'll need

- White cardstock paper
- Red fine-point marker
- Red extra-fine-point permanent marker
- Black extra-fine-point marker

instructions

1 Doodle an outer frame for the portrait using a red fine-point marker. Ⓐ

2 Doodle the contour line of the featured character inside the frame, using the same red marker. Ⓑ

3 Fill in the space between the outer frame and the contour line with the same red marker, leaving the area inside the contour line uncolored. Ⓒ

4 Use a red extra-fine point marker to doodle the details inside the white area including the face, shirt, and hair. Ⓓ

5 Use a black extra-fine-point marker to doodle extra details, such as the eyes, mouth, freckles, bow, and hair accessories. Ⓔ

Ⓐ

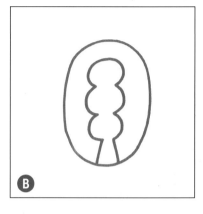

Ⓑ

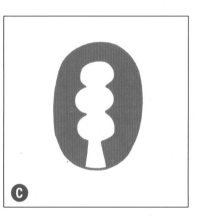

Ⓒ

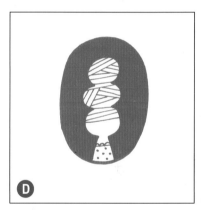

Ⓓ

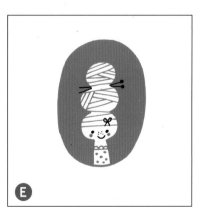

Ⓔ

tip

Try a different color than red, or try more than two colors (perhaps red, blue, and black), but keep the palette limited to mimic the simple illustration style of these sweet doodles.

FOLK ART GARDEN

DOODLE PROMPT: Doodle a set of mirrored elements to form a folk art motif.

› try it

Use a black brush-tip pen to doodle a flower with a long stem at the horizontal center of your paper. Add a doodled element to the left side of the flower, then doodle the same element to the right side of the flower, but reversed (mirror image) so it looks symmetrical. Continue adding mirrored doodles until the page is filled—or you can stop at any point, if you don't want to fill the whole page. Keep your lines loose and casual for the folk art quality.

HEART

DOODLE PROMPT: Use a pen and ink to create a detailed and delicate doodle within the boundary of a shape—in this case, a heart.

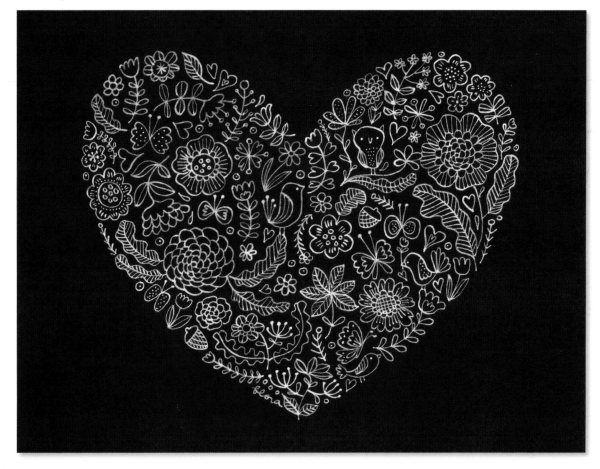

try it

On a piece of brown or colored cardstock, draw a big heart with a pencil, as lightly as you can. This shape will serve as the boundary.

Dip your pen nib directly into a bottle of white acrylic artists' ink. Make sure you have enough ink on the nib so that it flows nicely. Start doodling and stay within the boundary of the penciled shape. An alternative is to use a white gel pen.

One approach is to doodle along inside the boundary first to form the shape of the heart, but any way you want to do it is fine. Just remember to make the boundary doodles touch the pencil line. When the ink is dry, lightly erase the pencil line.

BIG Cat, LITTLE Kitty

DOODLE PROMPT: Tear out a paper shape and use it as a stencil to create a doodle base.

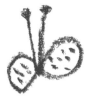

what you'll need

- White copy paper
- Woodless graphite pencil: 8B
- Stencil brush: #8
- Cardstock
- Matte fixative spray

instructions

1 Take a piece of ordinary white copy paper and tear out a shape freehand. You can also sketch out the shape on the paper first and then tear it out by following the sketch. Do not use scissors. The torn paper will give the paper's edge a soft and organic feel. **A**

2 On a separate piece of copy paper, use a graphite pencil to make very dark marks. The harder and darker the marks, the better, since we will be "harvesting" the graphite pencil powder from these marks in the next step. **B**

3 Press the stencil brush into the dark pencil marks you just made on the paper. Move the stencil brush around and let the bristles pick up some of the pencil powder.

4 Position the paper stencil from step 1 on a piece of cardstock. Hold down the paper stencil with one hand and stencil around the edges with a loaded brush. Repeat steps 2 and 3 as needed to load up enough pencil powder to finish this step. **C**

5 Remove the paper stencil to reveal the shape on the cardstock. It should look soft and pretty. Ⓓ

6 Consider the shape revealed by the stencil work and decide what it looks like to you. Doodle in the details using the same graphite pencil. My shape looked like a cat's body to me, so I turned it into a big cat and added doodled elements for the face, whiskers, ears, collar, legs, and tail. I also repeated steps 1 through 5 to add a smaller layer of stenciling for a kitty. I also added a scalloped frame.

7 Spray the finished piece with a couple of coats of matte fixative to protect it, and to prevent the pencil powder from smearing or rubbing off.

Ⓓ

tips

- Do not use an eraser during this process, even if you feel you have made a mistake. The eraser will cause the work to get dirty and messy.
- This is a fun doodle exercise for kids. Have them tear out lots of paper shapes, stencil them onto cardstock, and turn them into all kinds of imaginary creatures!

DOODLE MEDLEY

DOODLE PROMPT: Start anywhere on the page with a small element and grow that into an interactive shape that fills the page.

try it

Use a black fine-point marker to doodle the first element anywhere on your paper. I started with a flower-like shape. Observe the first doodled element and react to it by adding a small doodled element onto it. Continue building the piece by doodling more lines and shapes that follow the contours of the previous elements. In other words, allow what you just doodled to inform and inspire your next doodled element. At times, if you would like to start at a different spot on the paper without the new element touching the previous element, that's okay, as long as you can eventually doodle some lines that connect all of the elements together at the end. You can use this exercise on any size paper, for a small doodled card or a huge doodled poster.

designer: CORINNE DEAN

PAINT CHIP GUY

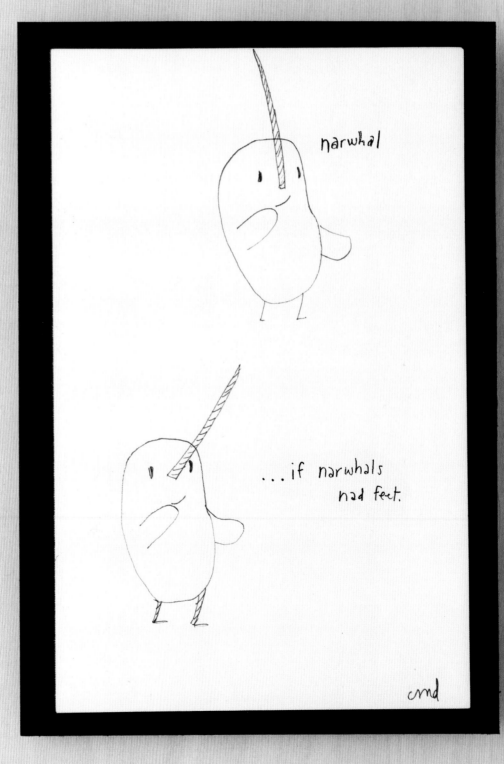

DOODLE PROMPT: Look around you and try to see what no one else sees in the everyday details. This prompt is about unleashing your imagination—to see images in the clouds, or a cute little guy on the corner of a bathroom mirror where the paint has chipped off.

what you'll need

- Good observational skills
- Camera
- Plain white copy paper
- Computer with Photoshop (optional)
- Printer (optional)
- Black fine-point marker

instructions

1 Much of the art of doodling is about being aware of the world around you, about noticing little details. These details are what inspire unique doodles. For this example, you will want to find something painted that has some paint chipping off. For me, that was the mirror in my bathroom.

2 Observe the chipped-off paint and imagine a shape or character. I saw a cute little monster guy with a fat body and short legs. Take a quick photo of the chipped paint to use as a reference for your doodles. The photo can be a quick digital one on your phone. Nothing fancy.

3 Print out your photo and doodle directly on the printout; or if you prefer, open up the photo in Photoshop and doodle in details digitally. Ⓐ

4 Doodle and name the character inspired by the chipped-off paint. I named my character Narwhal. Once you have the basic body shape figured out, doodle the character with different types of facial features. Maybe he has a super long nose, or crooked teeth, or little horns. Try out different feet. Maybe they are short and stubby. Or maybe they are slightly longer with claws. Ⓑ

5 Doodle fun accessories like a party hat, a pencil, purse, hair bows, hair, or whatever else comes to mind!

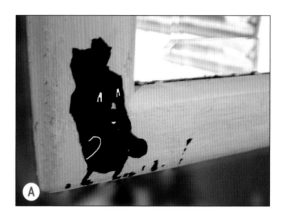

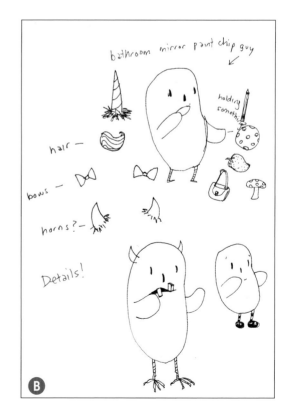

PILLOW SHARKY

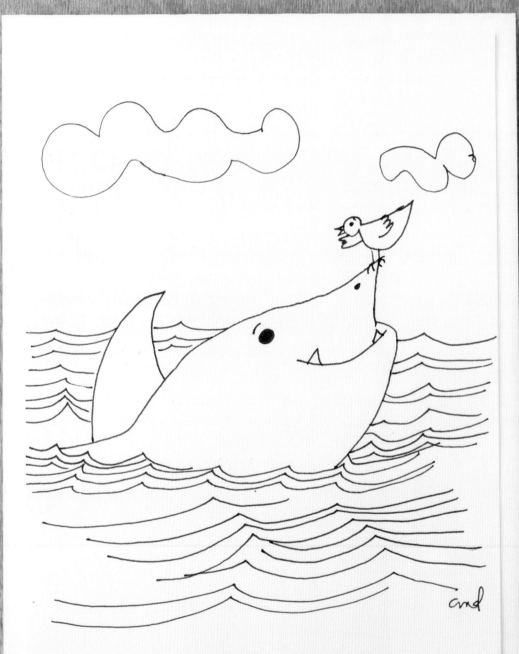

DOODLE PROMPT: The more you look at your surroundings and notice details that others miss, the more addicting it will become! You'll want to carry your camera with you at all times to capture inspiration for your next doodled character.

what you'll need

- Good observational skills
- Camera
- Plain white copy paper
- Computer with Photoshop (optional)
- Printer (optional)
- Black fine-point marker

instructions

1 The next time you wake from a night's sleep or from a nap, take a look at your pillow and ask yourself, "What do I see?"

2 The more crumpled the pillow the better, as the creases will start looking like facial features. I saw a shark from the corner of my pillow. Take a quick photo of the pillow to use as a reference for your doodles. Ⓐ

3 Print out your photo and doodle directly on the printout; or if you prefer, open up the photo in Photoshop and doodle in details digitally. Ⓑ

4 Doodle the character inspired by the pillow. For my Pillow Sharky, I doodled his face coming out of water and added lots of wavy lines. I made his facial features look friendly, to welcome the small bird that I doodled onto his nose. But not all pillow sharks have to be friendly. They could be ferocious, with violent waves and lighting bolts—whatever strikes your fancy. Ⓒ

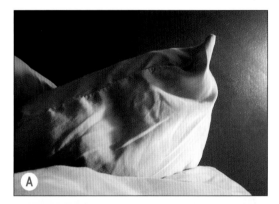

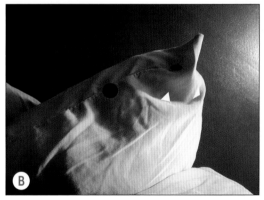

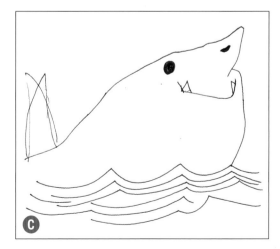

Corinne Dean

A MONSTER A DAY

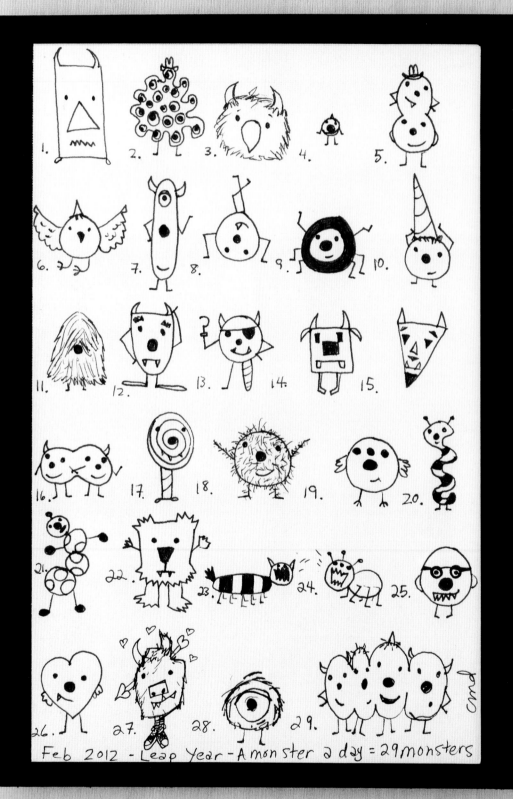

DOODLE PROMPT: Doodling a monster a day is a great way to get into the habit of doodling, and to challenge yourself to come up with lots of variations on a simple idea. Start with a basic shape and then add moods, limbs, and details. It's fun and easy!

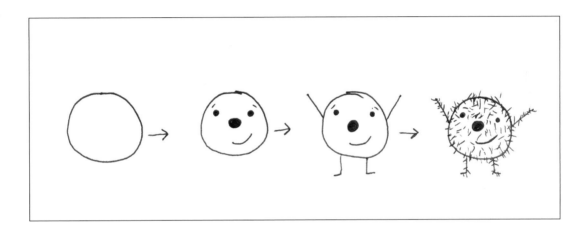

what you'll need

- Plain white copy paper
- Black fine-point marker

instructions

1 Monsters come in all shapes and sizes. They can be circles, triangles, squares, hearts, ovals, scallops, and more. The first step is to select a shape, such as a circle, to draw with a black fine-point marker on a piece of white paper.
2 Decide on the monster's mood and doodle their mood-based facial features.
3 Add limbs. These can be simple lines or squiggly shapes, or ornate lace-up shoes.
4 Add monsterly details, such as horns, teeth, claws, and lots of hair.

tips

- Create a family of monsters and doodle them on a page to tell a story.
- Create two monsters in love, to make a card that celebrates an engagement or an anniversary.
- Get the kids involved by having them cut out their doodled monsters and glue them onto popsicle sticks. Use the sticks to put on a monster show.

SASQUATCH TERRITORY

DOODLE PROMPT: This lesson shows how to make your own Sasquatch and his environment. Doodles like this can grow into their own comic strip or short story.

what you'll need

- Plain white paper
- Black fine-point marker

instructions

1 To make the head, start by pretending you are drawing a heart. Instead of making two bottom points that meet, spread them out and add zigzags for hair.

2 Continue on either side of the head by curving out to make arms with spikey hands, then curving back in for the body.

3 Add legs with spikey feet.

4 Doodle facial features to create the mood of your Sasquatch, making him look scary, happy, friendly, or surprised.

5 Add more details, including lots of body hair.

6 As you like, add fun details, such as a hat, bow tie, and a cane.

7 Doodle another Sasquatch friend with slightly different features.

8 Create an environment for the Sasquatch friends. Perhaps they are standing in a patch of grass, or camping in the wilderness, or having a picnic near a lake. Maybe they discover a new monster friend. Let the doodles lead the way into new imaginary worlds.

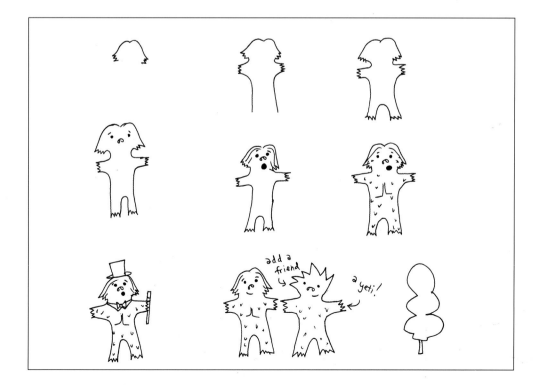

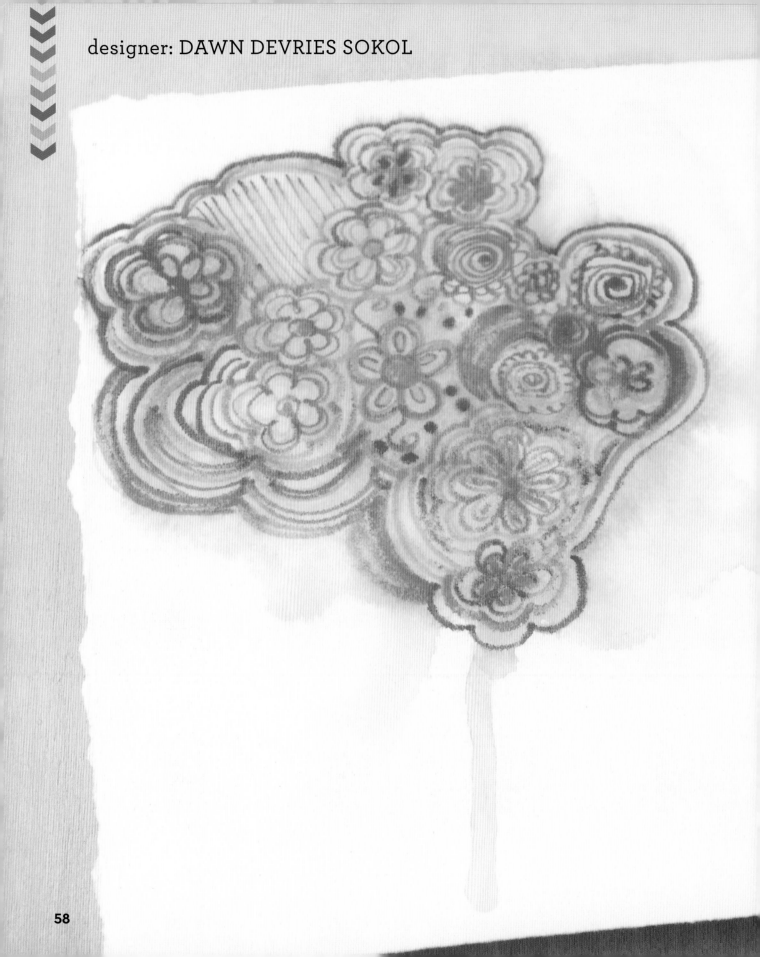

TIE-DYED Bouquet

DOODLE PROMPT: Who knew that paper could look tie-dyed? All you need is some wet watercolor paper and some bright watercolor pencil colors.

what you'll need

- Spray bottle filled with water
- Watercolor paper
- Watercolor pencils in orange, red, and yellow
- Paper towel

instructions

1 Use a spray bottle filled with water to wet your watercolor paper. Doodle a circle on it with an orange watercolor pencil. Ⓐ

2 Doodle petals with a red watercolor pencil. Ⓑ

3 Add another layer of petals with a yellow watercolor pencil. Ⓒ

4 Continue adding flowers and shapes to this flower, using the same color combination. Keep spraying the paper with water periodically to make sure that the paper stays wet. If a puddle of water appears, blot it with a paper towel or tilt the paper to make the water run down. This will give you that loose, mottled look of dyed fabric.

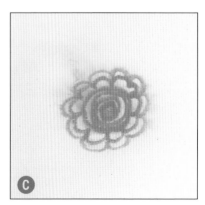

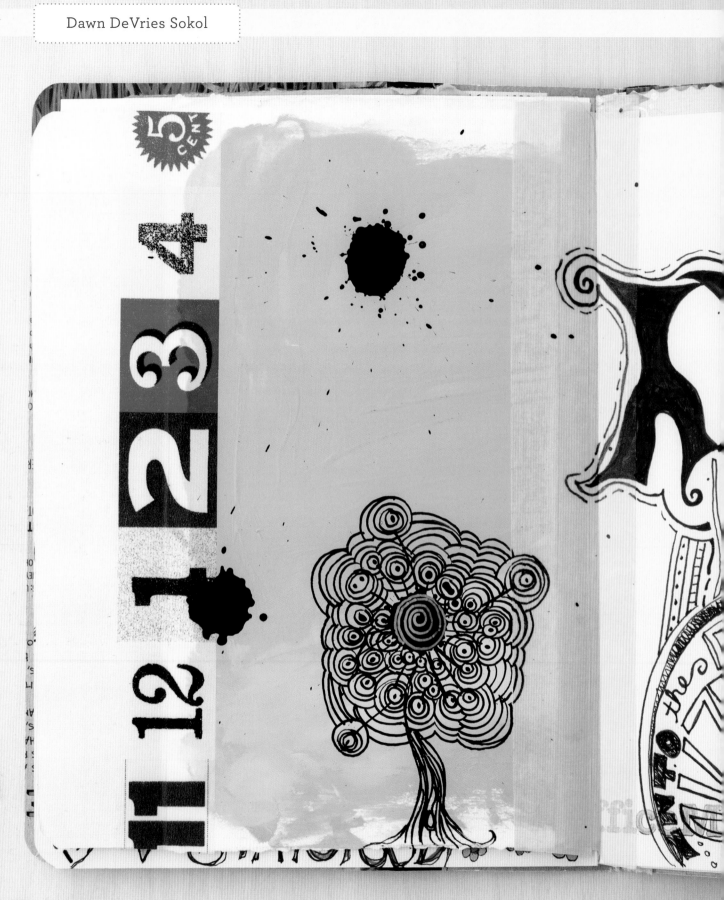

SPACE-AGE TREE

DOODLE PROMPT: Doodle a strange, spacey, and wonderfully weird bubble-like tree inspired by an ink splotch!

what you'll need

- Page from a journal that has been treated with color
- Black ink with dropper
- Black fine-point marker
- Blue fine-point paint pen

preparing journal pages

I love to doodle in my journal. Before the actual doodle, however, I like to add color to the pages so that I don't have to necessarily start doodling on a blank white page. If you have a journal, spend some time adding color to your pages with whatever types of paints you may have on hand. For the page shown here, I used aqua and yellow acrylic paints to brush onto the page. You can also use watercolors or markers. Once the pages are dry, you can go back to them and add your doodles.

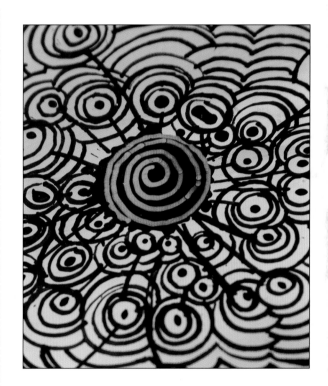

instructions

1 Load the dropper with black ink and hold it high above the paper. Let a couple of drops fall onto the paper.
2 Use a black marker to make small dots near one of the splotches.
3 Doodle circles around the dots and allow the circles to meld into one form that surrounds the splotch.
4 Doodle a tree trunk with wavy lines.
5 Add a spiral at the center of the splotch with a blue paint pen.

tip

- Use different colors of ink to make splotches in varying colors.
- Tilt the paper to deliberately cause some of the blotches to drip and run.

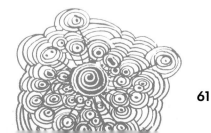

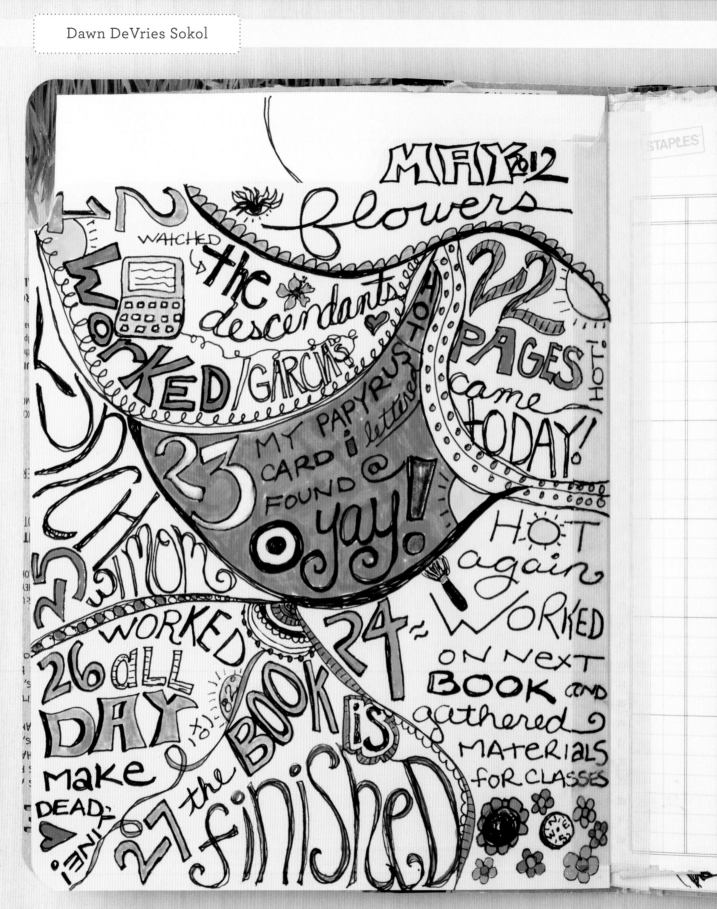

DAILY DOODLES

DOODLE PROMPT: Divide a blank page into seven spaces and doodle every day of the week in one of the spaces. You'll have a page filled with color and words and maybe even some surprises by the end of the week.

what you'll need

- Page from a journal
- Black fine-point marker
- Gel pens in assorted colors
- Markers in assorted colors

instructions

1 Use a black fine-point marker to divide a journal page into seven spaces with loose, uneven lines. Retrace these lines to make them look even looser.

2 Start doodling the first day of the week in one of the seven spaces of your choosing. Feel free to doodle along the division lines as well.

3 Repeat step 2 on the second day and continue throughout the week until all divided sections are filled with doodles.

4 As the week progresses, add color to the doodles with gel pens and markers. In other words, you don't have to "complete" each space at the end of each day. Approach the segment as a place to start each day but view the entire page as one that you can build upon throughout the week.

tip

This is a great exercise for the entire family. Have kids and adults pick a week to doodle together and then compare and contrast how the week was for each family member by reviewing the journal pages.

DOODLED Cupcakes

DOODLE PROMPT: Learn to doodle cupcakes that are completely fat-free and calorie-free!

what you'll need

- Black fine-point marker
- Watercolors
- Small paintbrush

getting inspired

Having a real life example of the subject matter you wish to draw is a good idea. So, if you like, either bake a cupcake or buy one to inspire your doodle. You can doodle a cupcake without looking at a real one, of course. Besides, you might be tempted to eat it before the doodle even begins!

instructions

1 Use a black fine-point marker to draw a small circle.
2 Draw a hemisphere under the circle, making sure that the bottom line has a slightly rounded curve. Ⓐ
3 Draw two vertical lines on either side of the hemisphere. Ⓑ
4 Draw another line at the bottom to connect the two vertical lines, matching the curve above it.
5 Starting from the bottom line, draw three tall thin scallops to represent the paper cupcake container. Ⓒ
6 Use watercolors and a small paintbrush to add color to your cupcake. Let dry.
7 Use the black marker to doodle facial features.

tip

To doodle a cupcake that is about to be eaten, do not draw the tall thin scallops along the bottom line. Instead, draw the peeled-away paper by making a wavy semicircle around the bottom of the cupcake. Add radiating lines for the paper folds. Doodle sad facial expressions.

Ⓐ

Ⓑ

Ⓒ

MAGICAL MILK

DOODLE PROMPT: Create "hidden" art and messages by doodling with milk on paper. It dries clear but reveals itself when heated!

what you'll need

- Milk
- Small cup
- Small paintbrush
- White cardstock
- Hair dryer

instructions

1 Pour some milk into a small cup. Dip a small paintbrush into the milk until it is well saturated.
2 Paint small doodles and words with the paintbrush on the white cardstock. Let it dry. You won't be able to really see what you are doodling, which is okay. That's part of the fun and magic of this prompt, because what you think you are doodling will be different from the end result.
3 When the milk is dry, the paper will look blank. Apply heat to the cardstock with a hairdryer, and watch your doodles emerge in a toasty brown color.

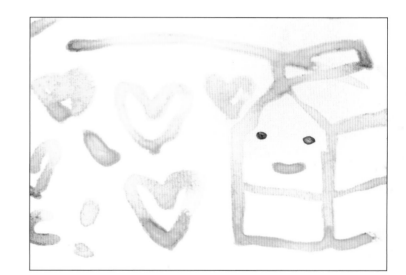

tip

Instead of a hair dryer, you can use a heat embossing tool or hold a hot iron or a lit candle (carefully!) close to the art.

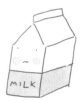

BACON FRIENDS

DOODLE PROMPT: Bacon isn't just fun to eat. It's fun to doodle! It's super easy and, believe it or not, can exude lots of personality.

Fact: BACON MAKES it BetteR.

learn how to draw a bacon pal, and you have the power to make everything more AWESOME!!

① dRAW A squiggle. ② add A parallel squiggle.

③ close off the ends.

④ COLOR iN with iRReguLAR reddish stRipes.

⑤ Add a fAce! DRAW moRe. BACON pARty!!

try it

Use a black fine-point marker to draw a squiggly line, then draw another line parallel to the first. Connect them with two straight horizontal lines. Use watercolors and a small paintbrush to add irregular reddish stripes. Let dry. Use the black marker to doodle facial features. Create a line of cute bacon strip friends and add colored hearts and other doodles to make their personalities come alive.

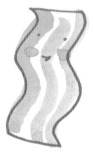

SWEET Combinations

DOODLE PROMPT: Grab a doodle-loving friend to make collaborative doodles based on combined lists. The results can be downright silly!

try it

Invite a friend to make a list of five adjectives or five pastries. While your friend makes one of the lists, you make the other list. Pair the first adjective to the first pastry from each list and take turns doodling the combinations. For example, if the first combination is a nerdy cupcake, use a black fine-point marker to draw a cupcake, then doodle facial features and accessories to make the cupcake look nerdy. Other examples include a sleepy donut, a pretty cookie, a dashing ice cream cone, and a chilly pie. Take turns using a small paintbrush and watercolors to add color to the sweet combinations doodles.

JUST DONUT!

DOODLE PROMPT: With just a few simple lines, create a donut (or a bagel)!

⟩ try it

Use a black fine-point marker to draw a circle. Draw a tiny circle in the center of the first circle. For a donut, draw a squiggly line inside the large circle (for the icing). For a bagel, draw a little squiggly line outside the large circle (for the cream cheese). Use watercolors and a small paintbrush to paint the icing light pink or other icing-like colors. Paint the bagel top a light brown. Use assorted markers to add tiny multicolored lines (for sprinkles) on the donut. Add small dots in either black or dark brown (for the sesame seeds) on the bagel.

Just donut! ♥

This is no mere circle.

Nope. it is a Delicious Opportunity.

it is so easy to create a donut!
(OR A BAGEL.)

① DRAW A CIRCLE IN THE CIRCLE.

② FOR A DONUT, DRAW A SQUIGGLY LINE INSIDE. FOR A BAGEL, Add a Little squiggle outside, for CREAM cheese. (optionAL)

Donut! BAGEL!

③ COLOR. PINK & Light BROWN FOR A DONUT, just Light brown FOR A BAGEL.

④ Add DOTS! MULTICOLORED For the donut; BLACK OR BROWN for the bAGEL.

yum!

RECYCLED Grocery List

DOODLE PROMPT: A grocery list can be seen as trash to discard, or as an opportunity to challenge yourself creatively. See how many things can be created from the shapes of the letters on your list.

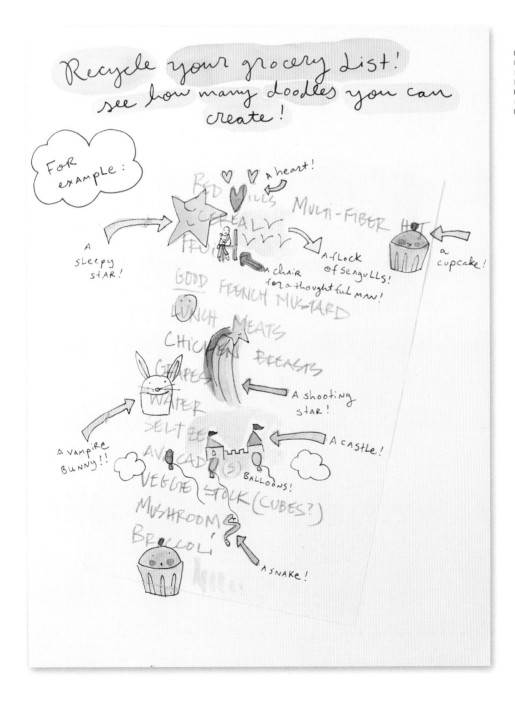

▼▼▼▼▼▼ **try it**

Take an old grocery list and look at it through new eyes. For example, the double Os in the word "cookies" could be eyes on a creature. Use a black fine-point marker to make assorted doodles sprouting off from your grocery list.

Adhere the doodled grocery list to a larger piece of white cardstock with a glue stick. Extend some of the doodles beyond the list and onto the cardstock. Add text that intersects both the cardstock and the list. Add color to some of the doodles with a small paintbrush and watercolor paints. If you like, add watercolor ovals, let them dry, then write on them.

designer: DINARA MIRTALIPOVA

FLOWER CLOUD

DOODLE PROMPT: Doodling flowers is a long-time favorite. Here's an approach for making layers of detailed flowers, then adding color.

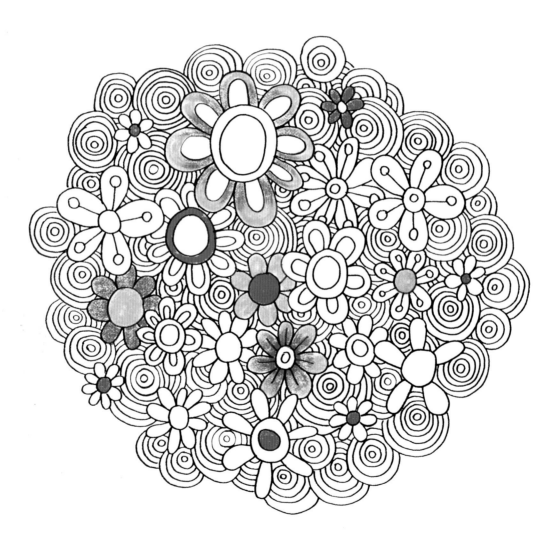

what you'll need

- White cardstock
- Black extra-fine-point marker
- Red and orange colored pencils

instructions

1 Doodle a few basic flower shapes that are spread out on the paper, making sure that there is space in between the flowers, and that none of them overlap each other. Ⓐ

2 Doodle additional flowers in some of the in-between spaces, drawing them to look like they are "behind" the first set of flowers. Do this by visualizing the first flower petals as overlapping the others, and end some of the new petals at the edges of the first flowers. Ⓑ

3 Doodle little circle clusters to fill the remaining in-between spaces. Continue until the perimeter of the final doodle is an imperfect, cloud-like circle. Ⓒ

4 Add splashes of color with red and orange colored pencils. Ⓓ

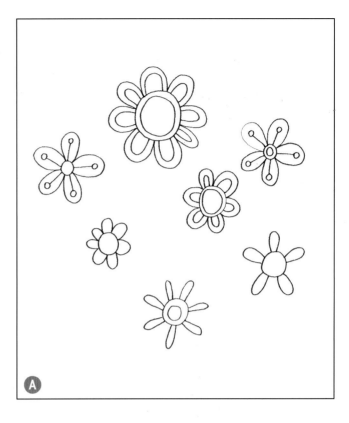

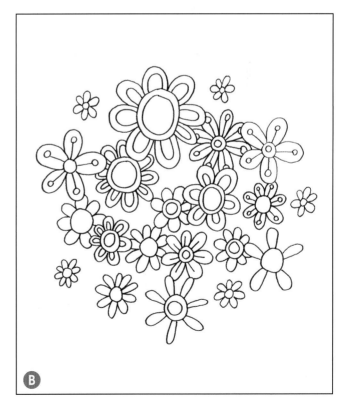

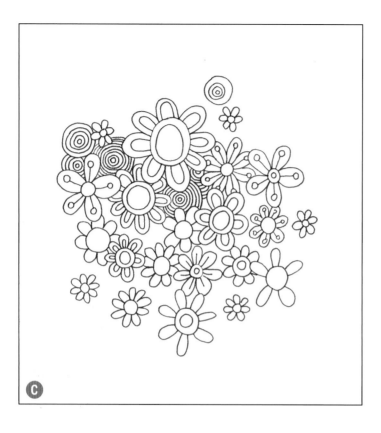

C

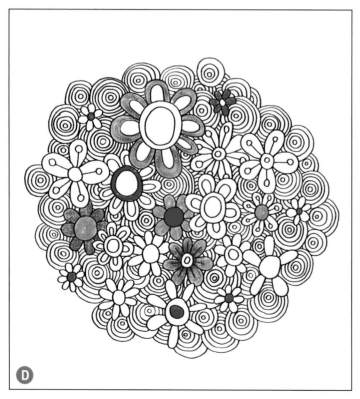

D

tips

- By using an extra-fine-point marker, the line work will look very delicate. Take your time with each stroke. Do not try to do this in a rush.
- All the lines should be connected and all circles closed. This will ensure that the final piece looks nice and neat.
- Even with just two colored pencils, you can make some interesting effects. For example, start by shading the inner portion of the flower's petals with the red pencil, and then finish the outer portion of the petals with an orange pencil for a gradated effect.
- Vary the pressure of the pencil, so that some areas have an intensity of color while other areas have a softer level of the color.

ACCIDENTAL HOUSE

DOODLE PROMPT: This doodle is a lesson on how to turn any "oops" doodle accidents that you don't like into something that is not so bad in the end.

try it

The doodle process for me does not involve the use of a pencil. I like to use my pen—without the option to erase anything—because it allows me to not over-think the process. Sometimes, when doodling with a pen, you'll find that you don't like how things look. For example, in this doodle I started with a house shape, two flowers with long stems and leaves, and a flower without a stem. When I looked at this early doodle, I didn't like it. I can't explain exactly why, but I didn't.

The first step for this process is for you to doodle something with a pen that you don't like.

Fix the doodle you don't like by simply adding more doodles around it. For me, I added more flowers, a chimney and window to the house, and another house. At this stage, it's important to keep doodles loose and large, rather than doing lots of detailed doodling.

Eventually, as you add more elements to the doodle, it will become a new doodle. At that point, start adding detailed line work and start filling in certain areas with the black marker to create contrast. Before you know it, you'll end up with a piece that you like. And that's because you didn't have the option to erase; only the option to continue with the pen and allow the doodle to evolve.

WATERCOLORED OWL

DOODLE PROMPT: Add fine detail and layers of watercolor to bring a simple shape to life.

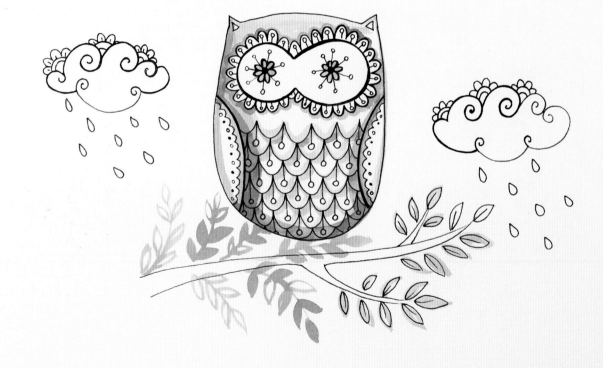

what you'll need

- Black extra-fine-point marker
- Heavyweight paper
- Small paintbrush
- Watercolors

instructions

1 With the black marker, doodle an owl by making an oval shape for the body, two points at the top for ears, and a slightly curved line between the ears for the top of the head. For the eyes, add a horizontal figure eight and two small flowers with petals. Draw two inside curves on both sides of the oval for the wings. (A)

2 For feathers, doodle rows of scallops in the main body area. Add scallops around the figure eight and scallops within the wings. Doodle a small tree twig with leaves right below the owl. (B)

3 Continue filling in with more intricate and detailed line work by adding circles, and lines.

4 Use a small paintbrush and watercolors in yellows and browns to color the owl and the leaves. Use the paintbrush to paint additional leaves to the branch.

5 Doodle clouds and raindrops on either side of the owl.

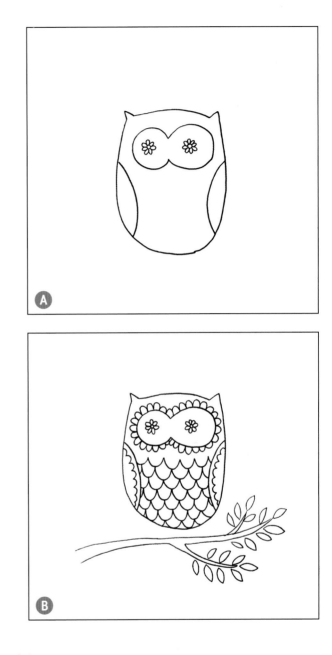

tip

Start the coloring process with a very light shade by diluting the watercolor with lots of water.
As you continue coloring, you can make the consistency less watery, and therefore darker. In other words, start lightly and slowly go darker.

FRAMED LOVE

DOODLE PROMPT: Hand-letter a word, and then doodle a frame around it with organic and geometric shapes.

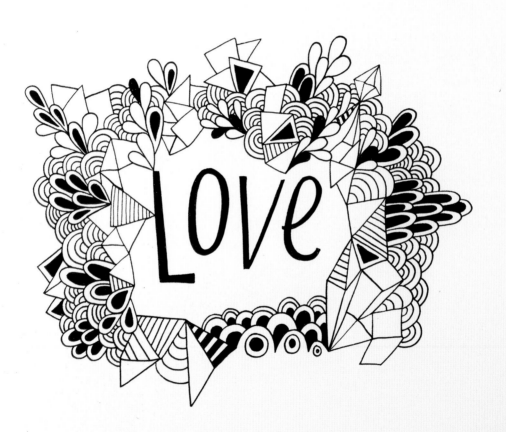

what you'll need

- White cardstock
- Black extra-fine-point marker

instructions

1 Select a favorite word and hand-letter it using simple lines. It's ok to combine uppercase and lowercase letters and for the letters to not be perfectly straight or aligned. Allowing the letters to be slightly wonky and imperfect adds to the charm of this process. Ⓐ

2 Without too much thinking, doodle around the word to create a frame, allowing some parts of the doodle to touch the word. Try to keep the doodling at this point nice and chunky without going into intricate details. Combine linear doodles, such as triangles and squares, with curvy doodles: scallops, petals, and teardrops. Ⓑ

3 Once the frame has been doodled, fill in some areas with more detailed line work. Fill in other areas with solid black to create contrast. Fill in the letters with solid black. Ⓒ

tip

Try making some frames with only loose and organic shapes and other frames with only geometric shapes. Add one or two colors to the doodled frame to accentuate areas of contrast in the design.

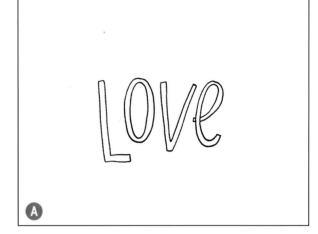

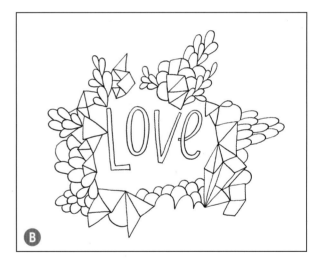

Bold and Folksy FLOWERS

DOODLE PROMPT: With only a black marker, doodle bold folk flower shapes.

try it

Doodle three large flowers by first making three large circles. Add petals to those circles in various ways. Doodle other small flowers in the space between the large flowers and also small flowers in the centers of the large flowers.

Fill each large flower with delicate patterns. There is no rule to this step and you can do whatever comes naturally to you. On my flowers, I added smaller petals, lines with smaller circles, and teardrop shapes within the first petal shapes.

Fill in some of the doodled areas. Create contrast by filling in patterns on a flower. For example, if you decide to fill in the teardrop shape within the petals of one of the flowers, fill in all the teardrop shapes. That will cause the other parts of the petals to remain white and create contrast.

Leave the doodle in black-and-white or add a pop of color with markers—or hand stitches with embroidery thread!

COLLECTION of the Cutest Animals

DOODLE PROMPT: My dog, Swizz, is the most adorable creature. I've studied his face and have learned to draw it pretty well. If you have an adorable pet, practice drawing its face. Once you have that down, this prompt can help you immortalize your pet by implanting its face onto the bodies of other animals.

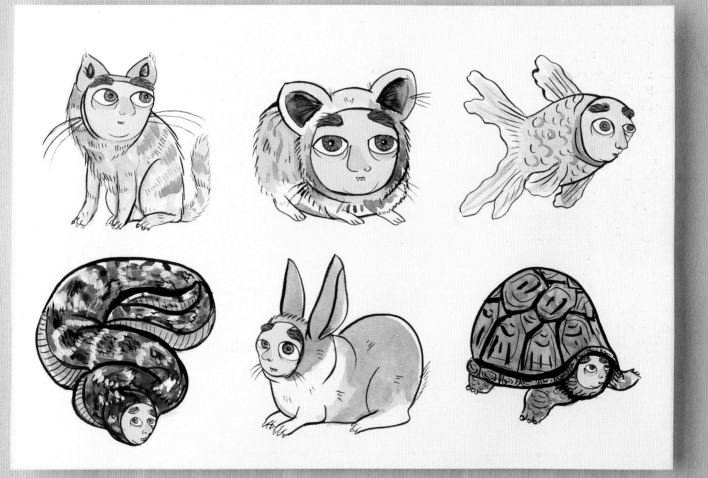

what you'll need

- Computer and printer
- White cardstock
- Mechanical pencil with 2H lead
- Ruler
- Small paintbrush
- Watercolors
- Black permanent ink
- Liner brush
- White eraser

instructions

1 Find copyright-free illustrations of assorted animals online and size them on your computer so that each illustration fits in an area that is approximately 3 x 3 inches (7.6 x 7.6 cm). Print out.

2 Use a mechanical pencil and ruler to lightly sketch two rows of three boxes, each 3 x 3 inches (7.6 x 7.6 cm).

3 Look at an illustration and sketch the main body parts into one of the boxes, leaving out the facial details. In the face area, sketch the face of your adorable pet.

4 Repeat step 3 until all boxes are filled with different animals, all with the facial features of your pet. Ⓐ

5 Add color to the characters with watercolors. Ⓑ

6 Use liner brushes and black permanent ink to outline the animals and add more details. Allow the paints and ink to thoroughly dry.

7 Use a white eraser to remove any wayward pencil marks.

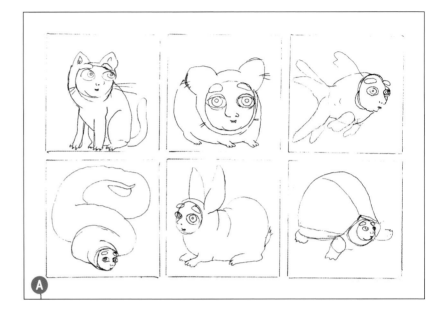

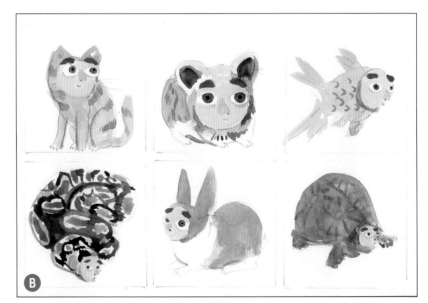

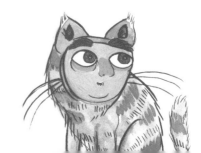

LEAF-NOSED BAT

DOODLE PROMPT: I love to invent animals with doodling. One great way to do this is by reading news stories about newly discovered species. For this creature, I read a news story that described a new leaf-nosed bat that had been identified in Vietnam.

try it

Read a news story, preferably without any illustrations, that describes something that interests you, such as animals, flowers, or outer space. After reading the article, highlight anything that pops out and lightly draw the imagined creature with a pencil. Use a small paintbrush and watercolors to add color to the creature. Use a small liner brush and black permanent ink to add more detailed doodles.

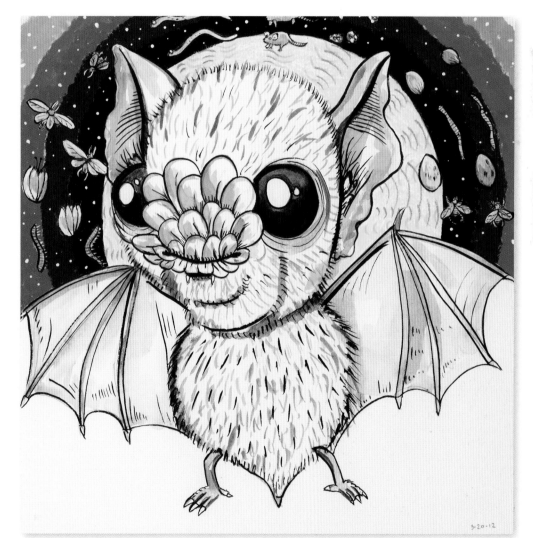

Lyrical Illustration

DOODLE PROMPT: Listen intently to the lyrics and melody of a narrative song and doodle a response.

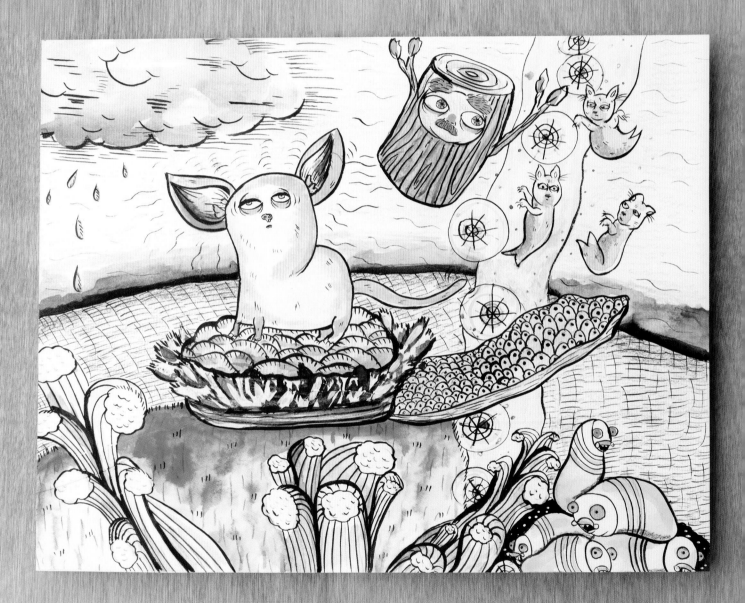

what you'll need

- Computer and printer
- Printout of lyrics to a favorite song
- White cardstock
- Mechanical pencil with 2H lead
- Small paintbrush
- Watercolors
- Liner brush
- Black permanent ink
- White eraser

instructions

1 Print out the lyrics to your favorite narrative song. The song that I chose for this prompt is titled "No One's Gonna Love You," by Band of Horses.

2 Turn up the volume on your chosen song while you read the printout of the lyrics. As you are listening, loosely doodle your response along the margins of the printout. Let the words of the song inspire images, shapes, and ideas. Underline or circle words as desired, and allow some characters to emerge. Ⓐ

3 Use a mechanical pencil to start laying out a doodle scene that incorporates the ideas from step 2 onto a piece of cardstock. Ⓑ

4 Once the entire paper is filled, use a small paintbrush and watercolors to add color to the doodled scene. Ⓒ

5 Use a liner brush and black permanent ink to outline the loose pencil doodles and also to add more details. Allow the paint and ink to thoroughly dry.

6 Use a white eraser to remove any wayward pencil marks.

Julie Armbruster

FANTASY Victorian Family

DOODLE PROMPT: Use an online name generator site and your imagination to construct a fantasy Victorian family portrait.

try it

Experiment with an online random name generator, such as www.kleimo.com/random/name.cfm. There are other name generator sites, so pick one that you like best. The idea is to request a set of names; you can specify however many names you want, genders, and so forth. (I requested five unusual mixed-gender names and the site came up with Winston, Emmett, Isa, Pearlie, and Buck.) Browse through some old Victorian photos and let the names inspire you to doodle a light outline of characters. Sketch a frame, as if the characters were posing for a photo. Add lines and shading with a small paintbrush and black permanent ink; vary the shade by diluting the ink with water.

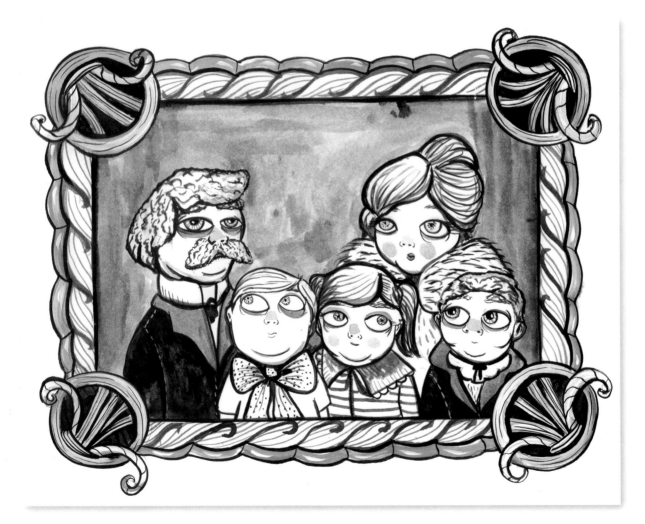

UNICORN SUNRISE

DOODLE PROMPT: Use a historic illustration as a foundation for an entirely new imaginative work. For this doodle, I used the *Allegory of the Vices*, etched by Flemish artist Jacques Horenbault in 1608.

try it

Find a historic illustration that you like, in a book or on the Internet. Make a photocopy or printout, then use charcoal and gesso to push and pull the characters around. Accentuate certain bodies and positions by outlining them with charcoal, while muting and de-emphasizing other details by loosely painting over them with gesso. Scan your new sketch, reduce the opacity, and print or photocopy the loose sketch onto cardstock. Use white gesso and sumi ink to continue pushing and pulling the composition and adding lots of doodled details. The finished piece will honor the original illustration, but most likely take new and unexpected turns as you build in your uniquely doodled details.

designer: STEPHANIE KUBO

designer: STEPHANIE KUBO

RIPPLES

DOODLE PROMPT: Create a ropey mass with accents of color that appears to touch the surface of water.

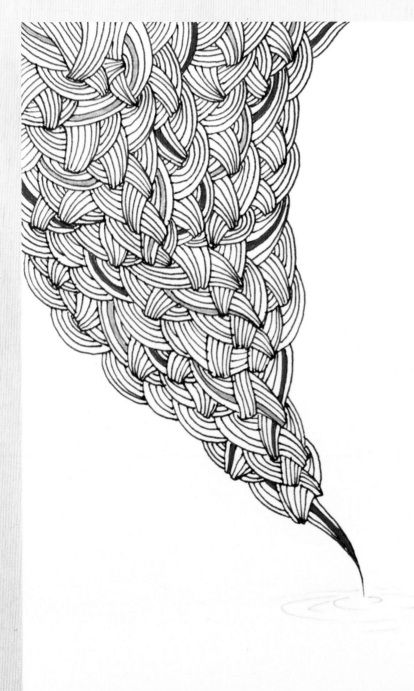

what you'll need

- Heavyweight 100 lb acid-free paper
- Fine-point markers in black, light blue, and dark blue

instructions

1 Starting at one corner of the paper, doodle a cluster of curved lines using a black fine-point marker. Make more clusters close to the first cluster in various directions so that they look like they overlap each other. Ⓐ

2 Continue building the mass, allowing the shape to grow and then taper off. Ⓑ

3 Use fine-point markers in light blue and dark blue to color in a few of the thin stripes within the clusters. Ⓒ

4 Make a dramatic sharp and thin point at the final cluster and add a dark blue accent in that final stripe. Doodle "ripples" with a light blue fine-point marker to suggest that the sharp point has touched a body of water. Ⓓ

tip

For patterns like this ropey one, I like to make the color accents look as if they could connect to each other. Depending on how you do it, it can make the viewer's eyes follow in different directions.

GROWING Together #1

DOODLE PROMPT:
For this prompt,
I encourage you
to refrain from
planning the end
result. Just allow the
organic shapes to
grow independently.

try it

Choose a starting point on the paper and doodle a stack of five small circles. Build upon that stack of circles by adding more stacks. Visualize the last circle doodled as laying on top of the next one for a layered effect.

As the mass begins to take shape, keep doodling in whatever "direction" the doodle takes you. Once you do one mass, you can start another mass on a different part of the paper.

Gradually, these organic shapes can and will run into each other and grow together.

GROWING Together #2

DOODLE PROMPT: This time, use two different pen colors and have the doodles grow into each other from opposite ends—for a spectacular result.

try it

Use a pink marker to start at one of the short edges of the paper. Doodle a row of stacked half-circles, as done in Growing Together #1. Build upon this row by adding more stacked half circles, visualizing as before how the circles overlap. Once the first clusters start moving toward the middle of the page, use a purple marker to start doodling the same motif on the opposite edge of the paper. Go back and forth between the pink and purple masses as you grow the patterns. When the patterns finally meet, decide which color will be doodled behind or in front of the other.

GRADATED BLOOM

DOODLE PROMPT: Use a single motif and multiple colors to experiment with gradation.

try it

Use a black fine-point marker to doodle an organic leaf pattern made of wavy lines. Doodle the leaf pattern several more times so it looks like a blooming flower. Build on this design by adding more leaves to make the bloom larger.

Now doodle a couple of transition rows, using a dark green marker for some of the lines in the leaf. Gradually switch to making leaves that are all dark green.

In another row, use a combination of dark green and light green to make more leaves. Finally, use only the light green marker to make the last rows of leaves. At the edge of the paper, make light green wavy lines.

FRAMED LINES

DOODLE PROMPT: Using only one element—the straight line—create an abstract piece that fills the page.

try it

Start by doodling a "frame" of long parallel lines at different angles. Allow them to intersect and create pockets of space. Within one of the pockets, doodle more clusters of parallel lines at varying angles. Create visual depth with clusters of lines that appear to be overlapping. Continue doodling clusters of lines until the entire page is filled. In certain areas, especially the centers, preserve some of the negative space by not filling in every space with lines.

designer: CYNTHIA SHAFFER

CIRCLE BACK

DOODLE PROMPT: Take time with this one. Feel the texture of the paper under your pen and make deliberate, smooth, circular marks.

what you'll need

- Watercolor paper
- Black extra-fine-point marker
- Colored pencils in light blue and brown

instructions

1 Use a black extra-fine-point marker and start doodling a large circle, then continue doodling without lifting the marker. Trace back over the first lines to add more circles radiating out from the original doodled circle.

2 Trace back over the doodles creating a second line around the doodles. Some lines can be far from the original lines and others can be close. **(A)**

3 Fill in the spaces that were created between the lines, some with solid black, others with small circles. Inside some of the large circles, doodle small circles with spokes; in others, doodle flowers. **(B)**

4 Using light blue and brown colored pencils, fill in the small circles and the outer edges of the flowers. **(C)**

tip

Instead of circles, try doodling other shapes in different sizes, such as squares or rectangles. Double back over the original doodled lines and then fill in any gaps between the lines to add interest and weight to the line quality.

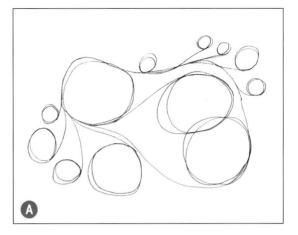

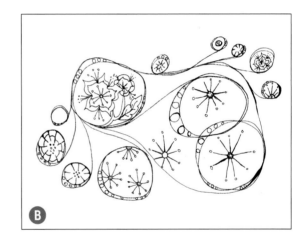

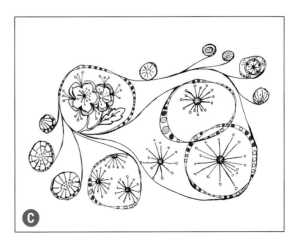

Cynthia Shaffer

HOLEY Rocks

DOODLE PROMPT: Find a rock with holes and cracks in it, and use them as inspiration to doodle directly on the rock.

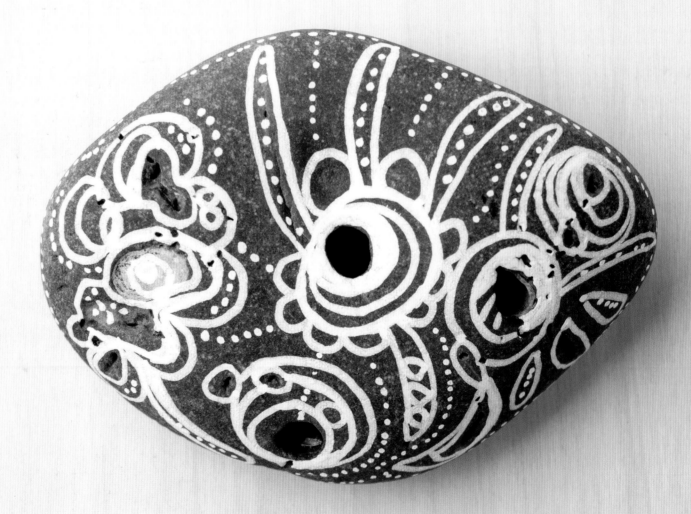

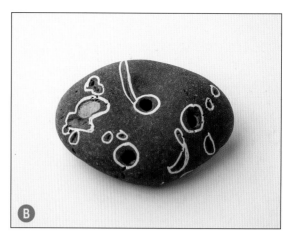
B

what you'll need

- Rock with holes and cracks
- White fine-point poster paint marker

instructions

1 Examine the rock that you have collected and look for prominent features such as holes, dips, cracks, and the overall shape of the rock. **Ⓐ**
2 Doodle circles around the holes. **Ⓑ**
3 Reexamine the rock and continue to doodle in response to the first marks you made. Add repetitive shapes to create continuity on the rock. **Ⓒ**

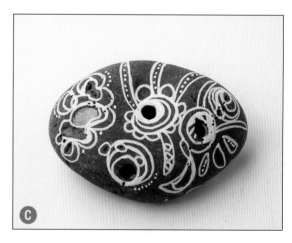
C

tips

- The shape of the rock may inspire a doodled animal, bug, snake, flower, or landscape.
- White poster paint markers are water-based and provide a rich opaque quality with good contrast on dark surfaces. To ensure permanence, spray any surface featuring poster paint doodles with a fixative.

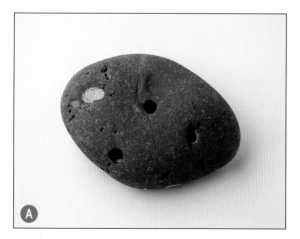
A

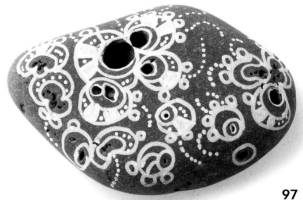

Cynthia Shaffer

BLACK SCRATCH Botanicals

DOODLE PROMPT: Use a black scratchboard to create this unique design—scratch your doodle into the surface of the board.

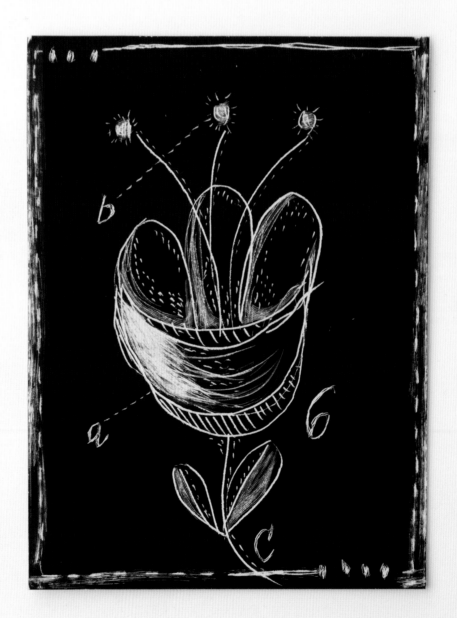

what you'll need

- Black scratchboard
- Scratchboard tools
- Ruler
- Sharp craft knife
- Panel of watercolor paper or greeting card

Scratchboards are thin boards of white clay coated with black India ink. They are manufactured by several different companies. They come in assorted sizes and are available in most art supply stores. A smaller board is approximately 5 x 7 inches (12.7 x 17.8 cm) and a larger board can be as big as 24 x 36 inches (61 x 91.4 cm). Regardless of the size board that you buy, you can trim it down to smaller sizes as needed with a sharp craft knife and ruler. Scratchboard tools are sharp instruments designed to lift, smear, and rub off parts of the India ink from the scratchboards.

instructions

1 Research botanical flowers in the library or on the Internet to get a feel for old botanical sketches.
2 Use the fine-point nib scratching tool to outline a flower shape and then add a few details.
3 Use the line tool to fill in parts of the flower to create some shadows. Ⓐ
4 Use the fiber brush tool to pop highlights and really scratch away the black surface. Ⓑ
5 With a ruler and sharp craft knife, trim the board to the desired size.
6 Add small details to create a frame. Ⓒ
7 Add numbers and letters to resemble an old botanical sketch.
8 Mount the botanical sketch onto a panel of watercolor paper or greeting card.

tip

Doodle a variety of flowers on one big piece of black scratchboard and then cut them up and mount them individually on greeting cards.

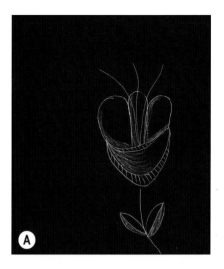

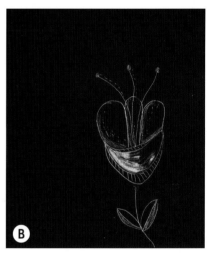

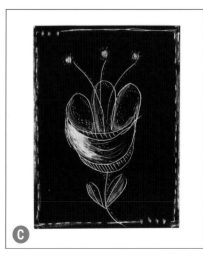

He gave her a passionate embrace, she sank to the floor in a fainting fit, and he rushed out with a gesture.

As soon as the door was shut, she rose very calmly, and inventoried the property.

"It is not much, but it is better than nothing. I am a daughter of France. I will be content with what is sent me; but I think the chain is oroide, and I know the shirt studs are snide."

A few moments later Henri entered. She received him with evident signs of pleasure.

"Therese," said the handsome young fellow, "I know that you love me. We attack the *canaille* to-morrow. I come to bid you farewell. I may never see you again!"

"Henri! I love you! But fight like a hero for France!"

"Adorable! Rapture! This is peaches! I will fight; I will be a hero—I am in the hero line just now. You have given me a new heart. Oh, Therese!"

And then there was more kissing and embracing, which was all very nice.

Then Henri rose and said he must go. Mars could not wait upon Venus as he called him.

"Must you go? Alas! the- Henri, should you fall, what would become of me."

"Die," said Henri, "and follow me to the next world."

Therese said to herself, "Not much, I thank you. I know a trick worth two of that. I prefer to live." But she said audibly:

"I cannot die, for I shall live to avenge you and France. But should you die on the field, the horrible Commune will take your watch, your chain, your personal effects, to continue this sacrilegious strife. Leave them with me."

Henri emptied his pockets, and took off his watch and everything on his person that had value, even to his cuff-buttons, and then Therese said:

"You will place your money in the hands of Duclos, the Notary. Give me the paper for that, for he is affected toward the Commune. I- before everything. When you return we will destroy the paper. Should you fall, I will spend it to avenge you."

B is for BERKLEE

DOODLE PROMPT: In an old book, doodle a single initial in honor of your pet, kid, or yourself. Then fill it with random line work, gesso, and watercolor pencils. This doodled B is for my cute pup named Berklee.

what you'll need

- Old book
- Black extra-fine-point marker
- Watercolor pencils
- White gesso
- Small paintbrush

instructions

1 Find an old book with pages that are still intact, smooth, but slightly yellowed and aged.

2 Doodle a simple capital B. Ⓐ

3 Doodle this letter again, adding width to the original letter. Add detail doodles like dots and scallops. Ⓑ

4 Paint the space around the letter and the spaces within the letter with white gesso. The gesso works great here because it does not add water to the doodle, which keeps the page from buckling or shrinking. Ⓒ

5 Use watercolor pencils to lightly add color to some parts of the doodled letter. Ⓓ

6 Dip a paintbrush into gesso and paint over the colored areas, mixing and blending the colors for a soft, dusty effect on the page.

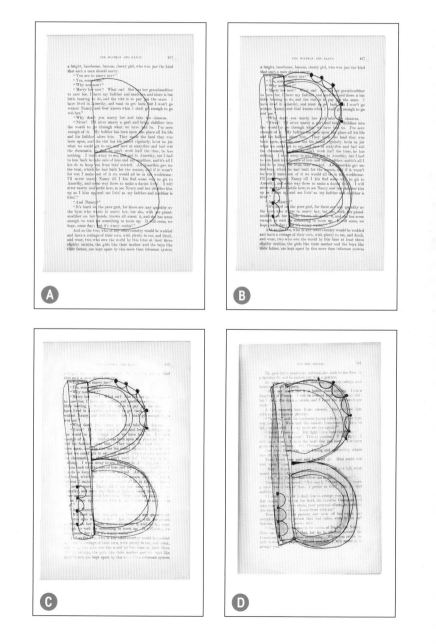

case which goes to the top of the house, and has charge of the buildings.

At night, say at eleven, the great doors guarding this common entrance are shut, and whoever desires to enter thereafter finds a bell-pull, the other end of which is at the head of the concierge's bed. She doesn't bother herself to get up and see who it is, but she merely pulls a wire, the bolt of the great door is withdrawn, you enter, and shutting the door after you — it fastens with a spring lock — go to your floor, and enter your own house.

Tibbitts likes this idea very much. He says that when you come home late at night, and not precisely in the condition to be accurate about things, there isn't any nonsense about finding a key first, and then going through the more delicate operations of finding the key-hole and getting the key in right side up. "All you have to do is to catch on that bell-pull, and the more unsteady you are, the better, for you lean back upon it, and your whole weight takes it." And he further remarked that there wasn't a concierge in Paris who wouldn't know his ring before he had been in the house a week.

The principal business of the concierge and her entire family is to keep the stairs clean. I once held that the Philadelphia servant girl would, were the supply of water to run out so that she could not wash sidewalks and marble steps, but she has a worthy rival in the Parisian. The stairs leading to the top of the building are kept sloppy all the time with the perpetual cleaning. Indeed so constantly is this going on that no time is given to enjoy the luxury of clean stairs. Not only the stairs are cleaned, but the very sides of the building are washed and scrubbed once in so many years, by law. If Paris only took as much pains with its inside as it does with its outside! But it doesn't.

Once inside the houses the first thing that strikes an American is the total absence of carpets; that is, carpets as we have them. The floors are of wood in many patterns, and in the center there may or may not be a rug, which covers, perhaps, two-thirds of the room. A room carpeted the entire surface is very rare, and I must say that therein the French housekeeper does better than the American. These rugs are

23

OLD TEXT DRESSES

DOODLE PROMPT: Read the words from a page of an old book. Imagine and doodle a dress suitable for the time period when the book was written.

what you'll need

- Old book
- Sharp craft knife
- Black extra-fine-point marker
- Small paintbrush
- White gesso
- Watercolor pencils

instructions

1 Flip through the pages of an old book and start reading some of the text. Use a sharp craft knife to cut out one of the pages that you like. Imagine what type of dress was worn during the time that the book was written, inspired by words on the page that you have selected.

2 Use a black extra-fine-point marker to doodle the outline of the dress. Ⓐ

C

D

3 Fill in the details, adding fullness to the skirt, princess seams, or anything else you imagine.
4 Doodle a mirror around the dress. Ⓑ
5 Use a small paintbrush to paint the mirror with white gesso.
6 Use watercolor pencils to lightly add color to the dress. Ⓒ
7 Dip the paintbrush into the gesso and blend the colored areas with it for a softened look. Ⓓ

POINTILLISM TREE

DOODLE PROMPT: Dots are all you need to create this simple tree on a page of an old book.

try it

Flip through the pages of an old book and get a feel for the weight of the letters in the book. Find a page that has some empty space for you to doodle in. Draw a simple circle with a black marker and then add dots around the circle with just the tip of the marker. Add some radiating dots from the circle and a line of dots down to the text. Continue to make more and more dots, concentrating in areas where you want to create a shadow. Extend the dots across the page and even down into the text.

KALEIDOSCOPES

DOODLE PROMPT: Kaleidoscopes are fun to doodle. Begin with a round shape in the middle, then work your way out by adding all sorts of swirls, squiggles, hearts, stars, dots, circles, scallops, or any simple shape that comes to mind. When you're done, transfer them onto fabric and embroider them into works of art!

what you'll need

FOR THE DOODLES
- White copy paper
- Pencil

FOR THE EMBROIDERY
(FOR EACH KALEIDOSCOPE)
- Light box (or window in well-lit area)
- White cotton fabric: 12 inches (30.5 cm) square
- Pencil
- 2-part wooden embroidery hoop in assorted sizes
- Embroidery needle
- Embroidery floss in assorted colors
- 2 yards (1.8 m) of satin ribbon, ½-inch (1.3 cm) wide
- Hot glue gun with glue sticks

instructions

Flowers & Trees
1 Draw a circle and add three intersecting lines to make it into a segmented pie. Draw another circle around the outside of the first circle. Ⓐ
2 Draw four hearts: one at the top, the bottom, the left, and the right of the circle. Draw four leaves in between the four hearts. Ⓑ
3 Add dotted line arches over the leaves, connecting the hearts. Draw large filled-in circles over the hearts. Draw two swirls over each filled-in circle. Ⓒ
4 Draw petals, lines, and dots on top of each arch and swirl. Ⓓ

tip

Although step-by-step instructions are provided to get you started, these kaleidoscope designs are most fun when you make them up as you go and turn your stream-of-consciousness doodle into something fun and unique. The main thing to remember is to repeat anything you add evenly around the circle, to keep a kind of snowflake-like symmetry.

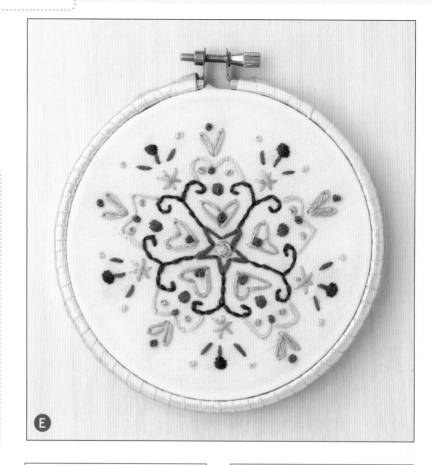

E

Fireworks (E)

1 Draw a star shape and add a dot in the center. (F)

2 Add a heart and dot above each corner in the star. Draw Y-shaped swirly lines at each point on the star. (G)

3 Add more dots and arches connecting the swirls. Add hearts and dots above the arches. (H)

4 Draw a star, lines, and dots above each Y shape. (I)

F

G

H

I

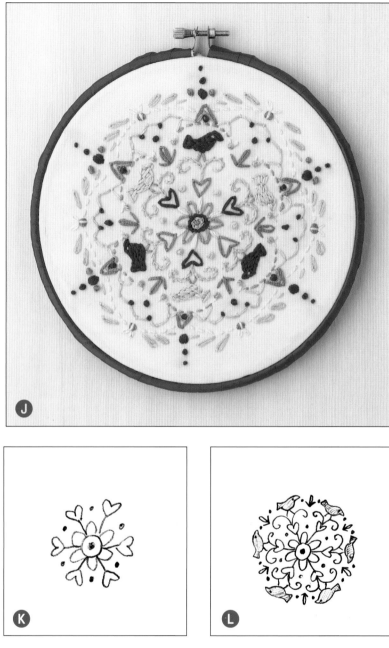

Birds & Bees Ⓙ

1 Draw a small circle with a dot in the middle. Draw six arches around the circle to form a flower. Draw a line and a heart between each petal. Add dots in between the hearts. Ⓚ

2 Draw two swirls over each heart, and a bird sitting on each set of swirls. Add lines and petals and two dots in between the birds. Ⓛ

3 Draw a dotted arch and 3 scallops over each bird. Add three more scallops connecting the first set and three dots underneath. Ⓜ

4 Draw a tiny bee over the center of each set of three scallops. Add dotted curved lines between the bees. Ⓝ

5 Add petals and dots around the edge to finish the design.

Embroidering Your Doodles

1 Place the doodle onto a light box and place the cotton fabric on top of the doodle. Use a pencil to trace the doodle onto the fabric. If you do not have a light box, tape the doodle onto a well-lit window. Place the fabric over the doodle and trace with a pencil.

2 Place the fabric into the embroidery hoop.

3 Use an embroidery needle and embroidery floss to start stitching the innermost section of the kaleidoscope. (See Simple Embroidery Stitches to the right.) Use a different color of embroidery floss for each group of motifs. For example, make the petals all one color, then make the next set of dots a different color, and so on.

4 Remove the outer ring of the hoop from the fabric to adhere the ribbon. Starting to one side of the outer screw on the outer ring of the hoop, adhere one end of the satin ribbon with a hot glue gun. Start wrapping the ribbon around the rim of the hoop, overlapping the edges of the ribbon as you go and hot-gluing every 2 to 3 inches (5.1 to 7.6 cm). Continue until the outer hoop is completely wrapped.

5 Secure the embroidered work between the outer and inner sections of the hoop. Pull the fabric taut and trim excess fabric in the back.

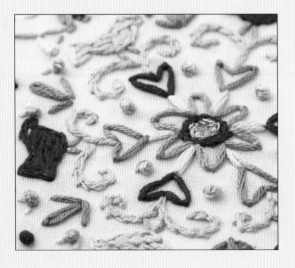

Simple Embroidery Stitches

Here is a chart of simple embroidery stitches that you can use to stitch the doodled kaleidoscope designs onto fabric.

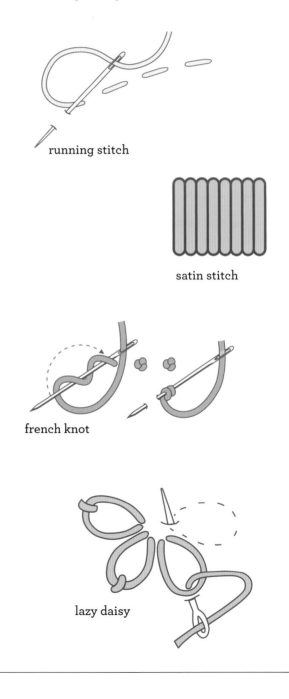

running stitch

satin stitch

french knot

lazy daisy

REPETITIONS

DOODLE PROMPT: Decorate the bottom or sides of a handwritten note, envelope, or scrapbook page by repeating doodled borders and corners.

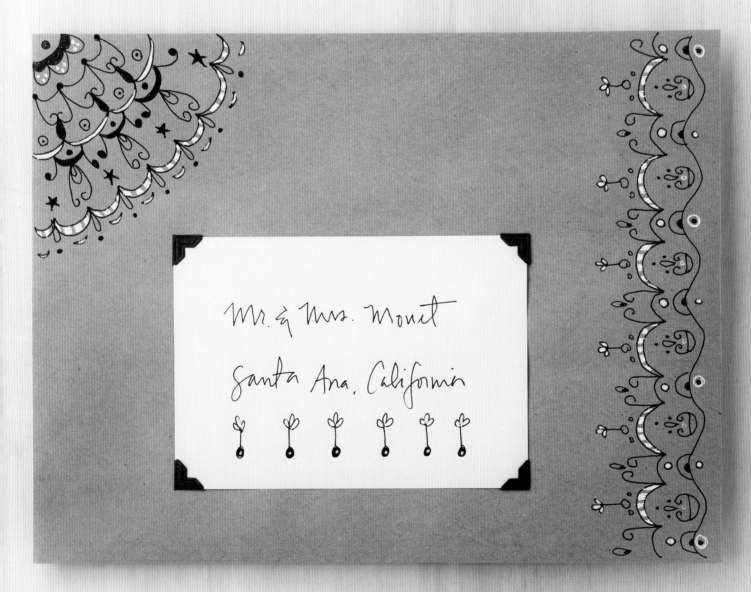

what you'll need

- Stationery, envelope, or scrapbook page
- Pencil (optional)
- Black fine-point marker
- White eraser (optional)
- White gel pen
- Photo corners (optional)

pencil or pen

You can start your doodles with a pencil, trace them with a black marker, and erase the pencil marks. Or forego the pencil and eraser and just doodle with a black marker, embracing any and all small imperfections.

instructions

Border Doodles (see page 111 and Ⓐ)

1 Draw a wavy line across the bottom or side of your paper. Draw alternate open and solid circles under each wave.

2 Draw arches on each rising wave: one small solid and a larger open one above it. Add crescent moon shapes above the sinking waves.

3 Add curls to the corners of each moon with a dot in between. Draw a larger circle above each arch.

4 Draw an inverted teardrop and three dots between each set of curls. Draw a scalloped line over the curls and dots.

5 Draw a second arch over every other scallop and curls at each corner.

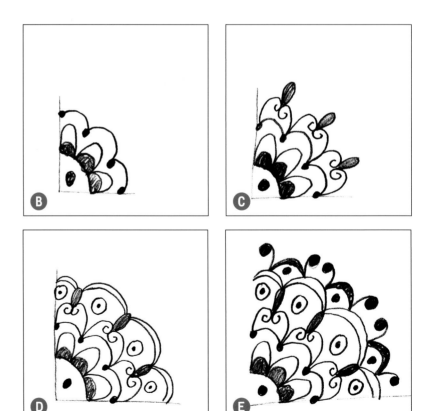

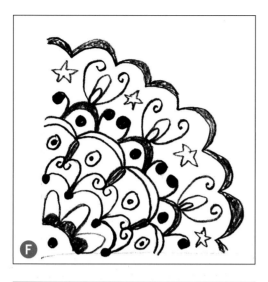

tip

You can make your own repeating corner or border designs. Don't worry too much if your lines are a little uneven or not exactly the same. Your doodles will be more interesting and unique if they are more organic looking. Try using the same methods to create asymmetrical designs by adding more shapes and lines to one side or different shapes on one side or the other.

6 Add inverted teardrops above the curls and three circles above each arch, making the center circle a bit larger.

7 Draw a three-petal flower on each large center circle.

Repeating Corner Doodles

1 Draw a quarter-circle in the bottom corner of your paper. Make a dot in the center.

2 Draw three petals on the circle line, one small solid and a larger open one above it. Add scallops and dots over the arches. **B**

3 Draw two curls over the top of each arch and a solid teardrop where they meet. **C**

4 Draw circles with dots inside between the teardrops and double arches connecting them at the top. **D**

5 Make a dot above each teardrop and a solid arch above each dot. From the base of each arch, draw curved lines with a dot on the end. **E**

6 Add an open teardrop and two curls to the top of each arch.

7 Draw stars in between the curls and a solid scalloped line over the entire design. **F**

8 Add alternating teardrops and dots at each corner of the scalloped line. Add upside-down crescent moons in between. **G**

Finishing

With a black fine-point marker, use these doodling methods to decorate a brown envelope. Add details with a white gel pen. Write the recipients' names directly on the envelope or on a separate piece of paper and then attach it to the envelope with photo corners.

designer: TERESA MCFAYDEN

STANDING

DOODLE PROMPT: Go find a group of people standing in line and doodle them from the side. This new perspective will result in a clever way to capture a scene.

what you'll need

- Camera
- Charcoal pencil
- Small paintbrush
- Watercolors

instructions

1 Find a row of people in line and take a photo of them from the side. It can be a quick photo that you take with your phone.

2 Look at the photo to study the proportions, wrinkles in clothing, hemlines, accessories, shoes, the way the arms fall, and the way the feet are positioned.

3 Use a charcoal pencil to make a quick and loose drawing of the people in line. Ⓐ

4 Draw the ground underfoot so that the people don't look like they are floating in air. The ground can be loose scribbled lines. Ⓑ

5 Give the doodle dimension by smearing the charcoal lines with a slightly wet finger.

6 Add more shading with light strokes of blue watercolor made with a small paintbrush.

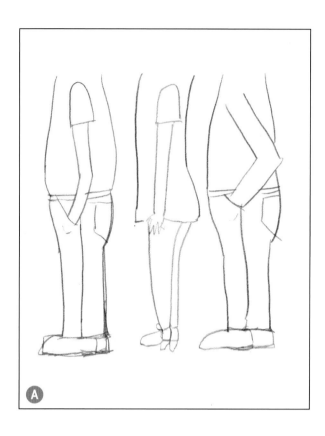

Ⓐ

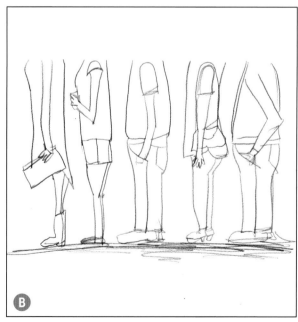

Ⓑ

BLIND CONTOUR Playlist

DOODLE PROMPT: Using your computer, portable music device, or phone, select a song from your favorite playlist and create a blind contour drawing of what you see as the song plays.

try it

As you listen to your favorite song (on repeat!) on your computer, portable music device, or phone, look at the displayed album or artist image and notice all the details of what you see. Without looking at your paper, start doodling the face of the artist. It will feel uncomfortable not looking at the paper, but the less you look, the better the doodle will be. Include parts of the display in your doodle, including the time, the volume control, and other small details located above and below the artist's face. Finish by drawing the frame of the phone. Use a black marker to trace over the pencil line and erase any unwanted marks.

Come to My WINDOW

DOODLE PROMPT: With just a few simple lines, doodle a window. Then add dimension with a bit of color and some shading.

try it

With a black fine-point marker, doodle four small rectangles in two rows of two. Doodle a large rectangle to frame the four small rectangles. Doodle the upper and lower casing with long horizontal lines that extend slightly beyond the frame, then join the lines at a slight angle. Add a splash of color with yellow and brown watercolors. Add shading with a charcoal pencil. Add more small, loose lines and details with the marker. Add words with the marker.

COME TO MY WINDOW

HAPPY FLOWER
Garland Frame

DOODLE PROMPT: One of the things I love about doodling is that you can use simple shapes over and over again. This prompt is about starting with a simple flower doodle and then repeating it along the edges of a page to create a garland frame. You can do this in your journal, on a card, or on stationery.

what you'll need

- Fountain pen loaded with black ink
- Journal
- Black extra-fine-point marker
- Colored markers

instructions

1 Along the edge of a journal page, use a fountain pen to doodle a simple flower, starting with a stack of circles. Add petals around the outer most circle and then decorate the petals or any of the circles with patterns. Ⓐ
2 Repeat step 1 to doodle more flowers around all edges of the journal page. Use a black extra-fine-point marker to make some of the more detailed doodles and marks.
3 Add doodled leaves, stems, and swirls to connect the flowers, so they start to look like a frame on the page. Ⓑ
4 Leave the doodled frame as is, or use colored markers to color some or all of the frame.

tips

- Garland frames are great in journals. Make frames in several pages of your journal and when the time is right, return to a framed page to add the journaling.
- Create garland doodles on cards and stationery.

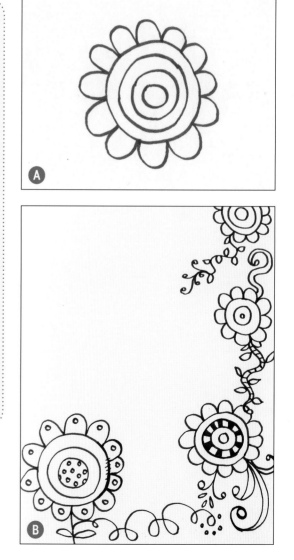

FLOCK OF BIRDS

DOODLE PROMPT: Design your own basic bird shape, then expand on that shape with all sorts of doodles and endless variations.

try it

Use an ink pen or marker to make a basic bird shape that looks like a chunky U, bulbous on one end and spikey on the other. Add an eye and a beak. Add a teardrop shape for a wing, and add lines to make two feet. Fill the page with more birds, making each one different by exaggerating a feature or adding patterns. Use markers to add color and patterns to the birds.

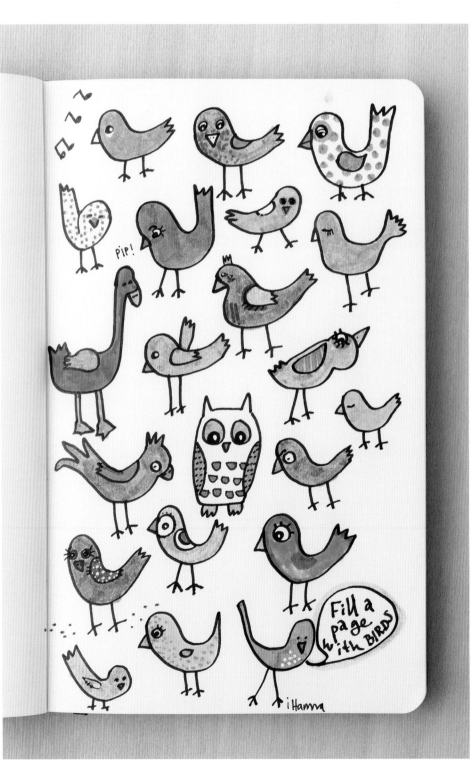

DAILY CHARACTER

DOODLE PROMPT: You don't need to draw perfect eyes or a nose to make a self-portrait. Instead of looking in the mirror and trying to copy those difficult lines, take a different approach. What are your main features today? Is it a striped sweater? Crazy hair? Is it the cat that's taking a nap in your lap or the way you feel like a princess when you're out and about? Use such questions as a starting point for a self-portrait that is fun and meaningful.

try it

Use an ink pen to make a basic head, neck, and upper body that represents you. Make a U shape for the head, two slightly curved lines for the neck, and an upside down U shape for the body. Add hair, lines for arms, ears, and basic facial features. Doodle the patterns you see on the sweater or shirt that you are wearing. Doodle add-ons such as thought bubbles, speech bubbles, eye glasses, and other accessories to bring your self-portrait to life. Leave the doodle as is or use colored markers to add color.

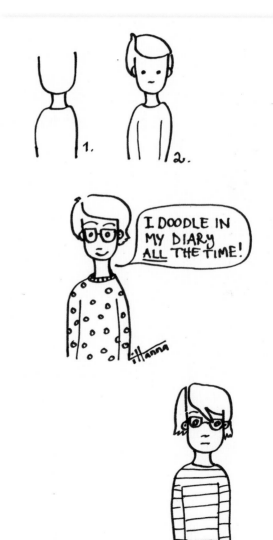

designer: MAFALDA LAEZZA

CUT, GLUED, and DOODLED Drops

DOODLE PROMPT: Who says a doodle has to start with pen and paper? Not me. I start my doodles with tissue paper shapes and you can too. Let the shape of a single raindrop or teardrop cut from tissue paper inspire you to doodle a whole bunch of cute, fun, and funny characters.

what you'll need

- Tissue paper scraps in assorted colors
- Hole-punch, standard size
- Scrap paper in assorted colors
- Scissors
- Glue stick
- White cardstock
- Pink marker
- Black fine-point marker
- White gel pen
- Red wax crayon
- Brown wax crayon
- Graph paper

fun with paper confetti

One thing I like to use in my doodles is paper confetti. It's a good idea to prepare a small supply of paper confetti ahead of time so that you can quickly grab what you need for the project you are working on. Simply use a hole punch and scraps of tissue paper, as well as other types of paper in assorted colors, and place the punched circles in a small jar or envelope.

instructions

Tissue Drop Faces

1 Cut assorted colors of tissue paper scraps into raindrop shapes. Cut these shapes with your scissors in a freeform and imperfect manner, without sketching them first.

2 Use a glue stick to adhere the shapes onto white cardstock. Make small dots at the top of the drops with a pink marker. Let dry.

3 Use a black fine-point marker to draw small faces on the lower portion of some of the drops. Small differences in the way you doodle the eyes, nose and mouth will create different characteristics for these tissue drop faces (shown at left).

Curious Elf

1 Cut a raindrop shape with a piece of pink tissue paper and adhere it with a glue stick to white cardstock, with the point at the top.

2 Use a black fine-point marker to doodle eyes, nose, mouth, hair, antlers, and legs. Fill in the eyes at the right corners of each eye to make the elf appear to be staring at something beside her. Doodle a speech bubble and hand letter the word "hello" in it.

3 Attach three pieces of paper confetti toward the top of the drop's point.

4 Use a white gel pen to add small details.

5 Use a red wax crayon to add the elf's cheeks (shown at left).

Nose with a Flu

1 Cut a raindrop shape with a piece of orange tissue paper and adhere it with a glue stick to white cardstock, with the point at the top. Cut a much smaller drop shape with gray tissue paper and adhere it beneath the orange drop.

2 Use a black fine-point marker to doodle a large U-shape for the face. Doodle facial features including closed eyes, eyebrows, mouth, ears, neck, shirt, and hair.

3 Use a brown wax crayon to trace over the face, and a few facial features.

4 Use a red wax crayon to add lines in the hair area.

5 Glue pieces of paper confetti for the cheeks and a couple of extra confetti pieces beneath the face.

6 Cut a piece of graph paper into the shape of a drop and adhere it to one side of the face. Hand-letter "etciu" (Italian for "atchoo") in the shape to represent a sneeze (shown at left).

GHOSTS ATTACK

DOODLE PROMPT: From an abstract pattern made of paper confetti, make doodles that tell a story—from ordinary to the unusual.

what you'll need

- Paper confetti (See Fun with Paper Confetti, page 123)
- Scissors
- Glue stick
- White cardstock
- Black fine-point marker

instructions

1 Use a glue stick to adhere paper confetti to your cardstock. Do this in a random manner, without trying to create an intended shape.

2 Observe the glued confetti and ask yourself what you see. Try to imagine a landscape, then use a black fine-point marker to doodle lines between the dots to form shapes. In my confetti, I saw a mountain, a small house, and a sun. I saw the land near a body of water with ripples and dots in the water. At this stage, it is important to make simple, geometric, and loose doodles. (A)

3 Use the black marker to doodle some detail. Add to the confetti pieces, if you like. (B)

4 Along with the small circus tent and the floating balloons, I decided to add ghosts that came to visit the happenings of this circus. So I cut teardrop shapes with gray tissue paper and added them to the cardstock with a glue stick. I added facial features to the ghosts with a black marker.

storytelling

The story that formed from my doodle is about a little circus that is surrounded by floating balloons and a large mountain. One day, the circus is attacked by three visiting ghosts! It could happen only in one's imagination. So, what's your story? Use the dots as a jumping off point to allow a tale to emerge. Add detailed doodles and maybe a few visiting creatures made from tissue paper.

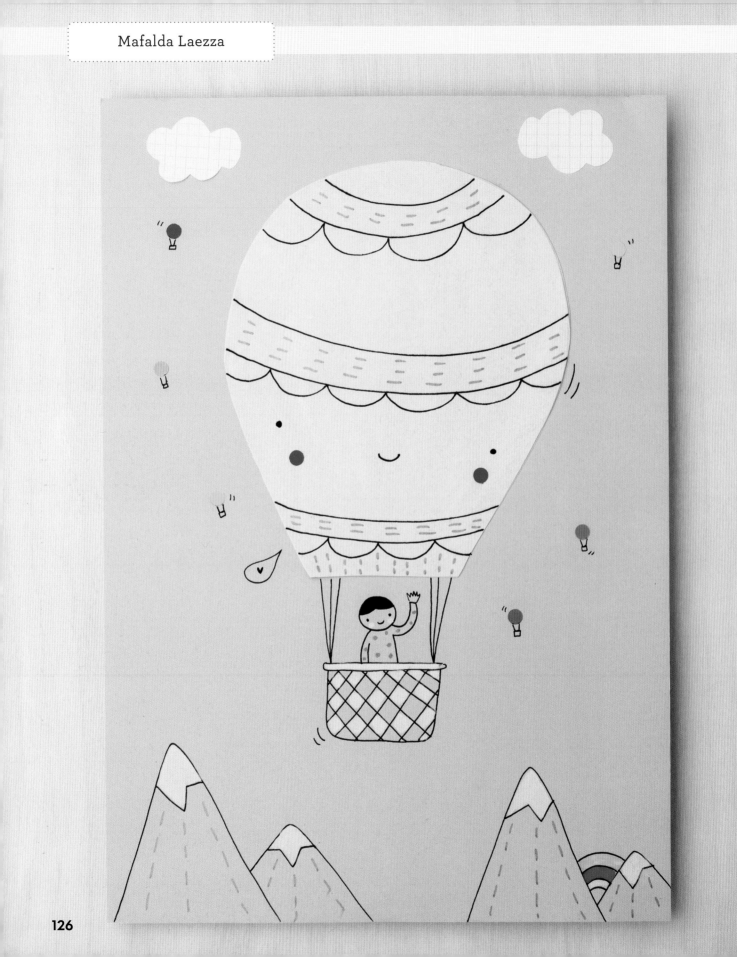

UP, UP, AND AWAY!

DOODLE LESSON: Doodle details to make a piece of white tissue paper come alive and take flight.

what you'll need

- White tissue paper
- Scissors
- Glue stick
- Light blue cardstock
- Black fine-point marker
- Paper confetti (See Fun with Paper Confetti, page 123)
- White gel pen
- Graph paper
- Markers in assorted colors

instructions

1 Use scissors to cut a piece of white tissue paper into the shape of a large teardrop. Cut off the point to make a straight, flat edge. This will be the lower portion of the hot air balloon.
2 Use a glue stick to adhere the hot air balloon onto light blue cardstock, with the curved portion of the balloon at the top.
3 Use a black fine-point marker to make two triangles on both sides of the lower edge of the balloon. Draw a straight line down the middle of both triangles. Ⓐ
4 Attach the basket by drawing a thin rectangle with rounded corners, followed by a large rectangle with rounded corners right below it. Add crisscrossed diagonal lines to the large rectangle. Draw small movement lines near the balloon and near the basket. Ⓑ
5 Add lines, scallops, and simple facial features to the balloon.
6 Doodle a passenger and mountains. Use a white gel pen to fill in some of the diagonal squares on the basket. Ⓒ
7 Adhere paper confetti to the balloon for cheeks, and for smaller mini balloons in the sky. Cut clouds with graph paper and adhere toward the top. Add details to the mountains with a white gel pen and markers in assorted colors.

designer: PAMELA KERAVUORI

EASY Symmetrical Hearts

DOODLE PROMPT: With a bottle cap as a template, it's easy to draw a symmetrical heart filled with lots of doodles.

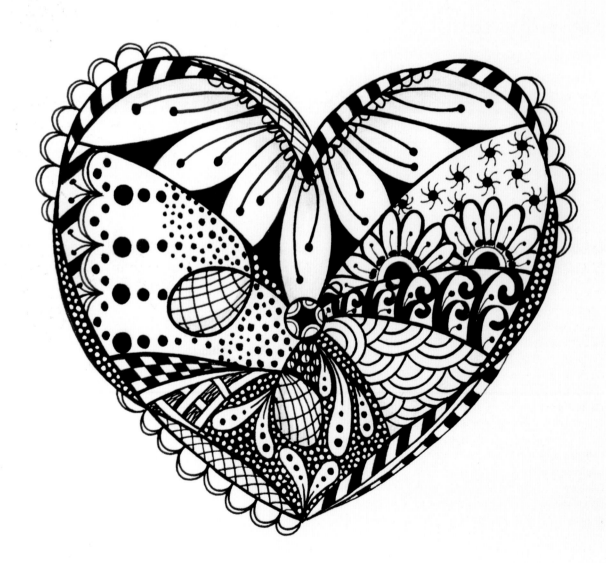

what you'll need

- Heavyweight paper
- Small round lid or bottle cap
- Graphite pencil
- Ruler
- White eraser
- Black fine-point marker
- Black brush-tip marker
- Black medium-point marker

instructions

1 Using a pencil and a small round lid or a bottle cap, trace two circles side by side, with their inside edges touching.

2 Use a ruler to draw a straight line down the middle, starting where the circles touch.

3 Use a black fine-point marker to trace the upper parts of the circles from the top of the heart, continuing from the outside curves down to the end of the center line. Erase the pencil lines.

4 Add doodled embellishments to the heart. Experiment with filling the heart with geometric designs, such as stripes, circles, scallops, vines, diamonds, and flowers. Use a combination of fine-point, brush-tip, and medium-point markers to fill in selected parts of the doodles.

ideas

- Use two different-sized bottle caps to make an asymmetrical heart.
- Make the center line shorter for a short chunky heart. Make the center line longer to make a longer skinny heart.
- Use a medium-point marker to make a circle at the center of the heart and then lines from the circle to the heart's edges to divide the heart into segments. Doodle different motifs within each of the segments.

Pamela Keravuori

PENNANTS

DOODLE PROMPT: Doodle a variety of pennants, using basic shapes such as triangles, rectangles, inverted triangles, and scallops.

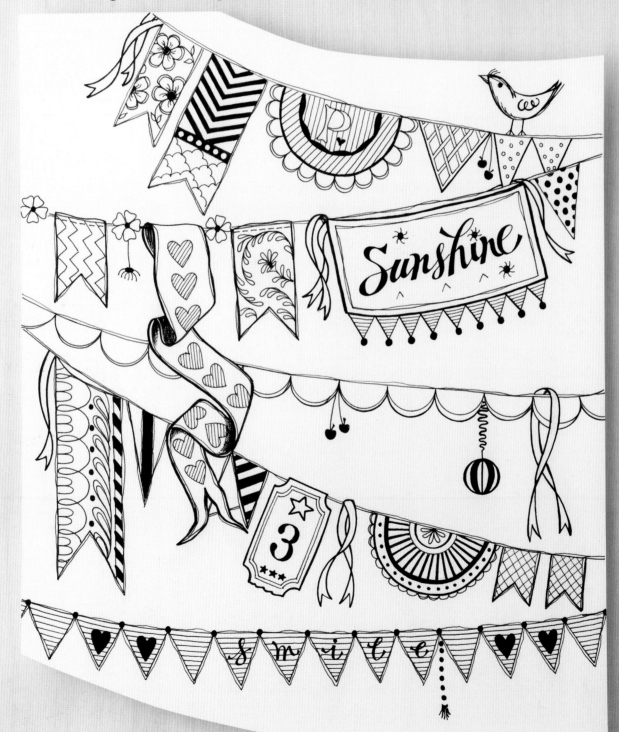

what you'll need

- Black fine-point marker
- Heavyweight paper
- Small paintbrush
- Watercolors
- Black brush-tip marker
- Black medium-point marker

instructions

Triangular Pennants

1 Use a black fine-point marker to draw a triangle. Trace over the triangle again with the marker so that there is a double line. This will add looseness and playfulness to the doodle. Ⓐ
2 Extend the line from the top of the triangle and suspend more triangles from that line, leaving a little space between each triangle. Make the line straight or drape it in a curve from end to end.
3 Add doodled embellishments, such as flowers or ribbons in between each of the triangles.
4 Use a combination of fine-point, brush-tip, and medium-point markers to make assorted doodle motifs within each triangle, such as dots, flowers, vines, and scallops.

Rectangular Pennants

1 Use a pencil to draw a rectangle. At the bottom end, draw an inverted triangle and erase the bottom edge of the rectangle to make an indented pennant. Ⓑ
2 Use a black fine-point marker to trace the pennant shape. Trace over the shape again with the marker to create a double line.

3 Extend the top line from the top of the rectangle and suspend more rectangular pennants from that line, leaving a little space between each pennant.
4 Add doodled embellishments in between each of the pennants.
5 Use a combination of fine-point, brush-tip, and medium-point markers to make assorted doodle motifs within each pennant.

Flag Pennants

1 Use a black fine-point marker to draw two parallel lines close to each other, with a circle at the top of the lines to create a pole. Ⓒ
2 Draw an arched line from the top to another point on the pole, making it long enough for adding a number of horizontal flags.
3 Doodle a pair of lines that cross over near the end, then end in a single pointed tail or a double indented tail.
4 Use a combination of fine-point, brush-tip, and medium-point markers to add doodles to the pole and the pennants.

Scalloped Pennants

1 Draw a line that curves to the right and then curves back to the left.
2 Doodle connected scallops along the curved lines. Trace over the scallops again with the marker to make double lines. Ⓓ
3 Add doodled embellishments at both ends of the line.

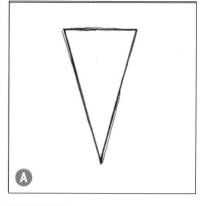

Ⓐ

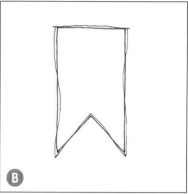

Ⓑ

Ⓒ

Ⓓ

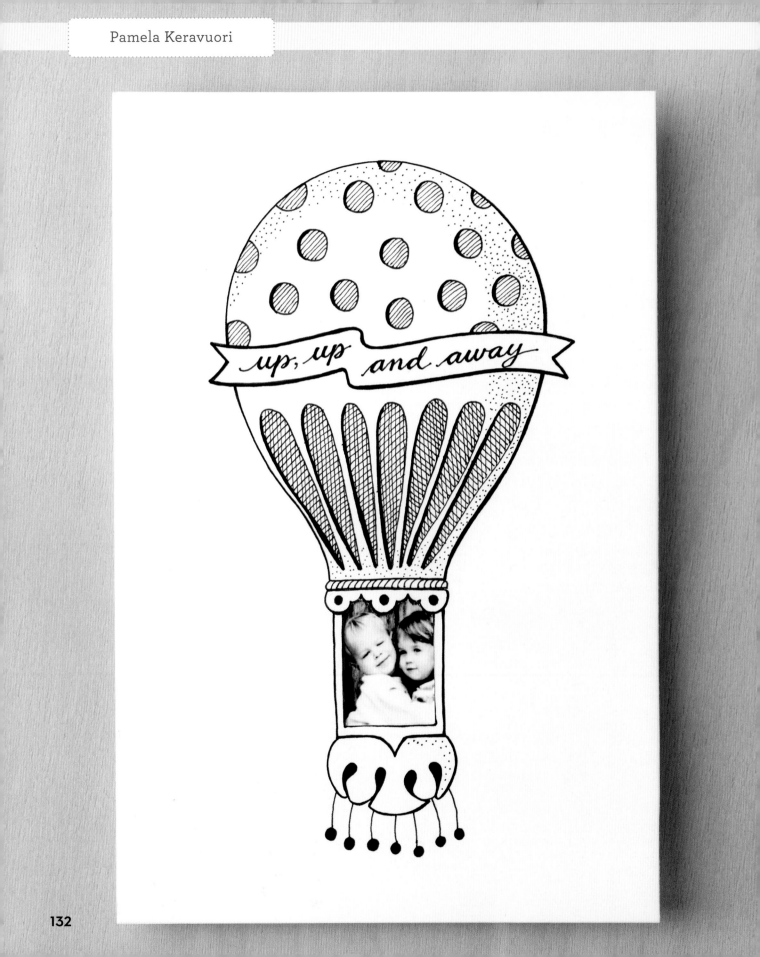

HOT AIR Balloons

DOODLE PROMPT: Doodle a hot air balloon using a light bulb shape and a small box or basket below it. Then add lines for ropes and lots of doodled embellishments.

what you'll need

- Heavyweight paper
- Graphite pencil
- Cup or small round lid (optional)
- Black fine-point marker
- White eraser

instructions

1 Use a pencil to doodle a light bulb shape freehand. Or, if you want to be more precise, use a round lid or cup as a template for the half circle at the top of the balloon; then continue down the sides with lines that curve inwardly, narrowing the shape. Ⓐ

2 Leave some space below the balloon and use the pencil to doodle a small square.

3 Transform the square into a hanging basket by adding doodles that look like ropes along the edges of the box.

4 From the widest part of the balloon, draw lines that represent ropes connecting to the corners of the basket. Try a few ropes or many, depending on your desired look.

5 Doodle embellishments on the balloon, such as vertical stripes and horizontal bands. Add flowing pennants around the balloon or more balloons on top, and maybe doodle some passengers in the basket as well.

6 Use a black fine-point marker to ink all of the doodles made in pencil. Don't worry too much about retracing the pencil lines exactly. Allow the ink to dry and carefully erase the pencil marks.

Ⓐ

tips

- Create a balloon with the square attached to the balloon. Cut out the inner portion of the square to serve as a frame for a small photo. Attach the photo by placing double-stick tape along the edges of the photo and pressing it on the backside of the doodled hot air balloon, positioned and centered in the cut-out frame.
- Try drawing the basket a number of different ways, including something decorative that doesn't necessarily look like a functional basket.
- Doodle small human figures as passengers of the balloon.

DOODLE BIRDS

DOODLE PROMPT: Here's an easy way to doodle a bird, starting with a big smile shape and then adding fun variations in beaks, wings, and tails.

try it

Use a black fine-point marker to draw a big open smile shape for the bird's body. Add a dot at one corner of the body for the eye and a triangle shape for the beak.

Add a smaller open smile shape inside the body for the wing. Add two legs, and retrace the body to give the doodle a looser and playful feel. Use a brush-tip marker to draw three or more curved teardrop shapes for the tail. Use the fine-point marker to add dots, lines, and other details to the birds.

From HOUSE to VILLAGE

DOODLE PROMPT: Use a few simple building parts to doodle a house or an entire village.

try it

Use a black fine-point marker to draw a horizon line with a bit of a curve. Doodle a simple house on top of the horizon line, using basic geometric shapes for the base, roof, windows, door, and chimney. Use the marker to double the lines of the shapes to add looseness to the doodle, and to add small spaces that can be colored in, if desired.

To create a village, extend the horizon line on either side of the first house. Add other houses and buildings, with variations to the shapes and roof heights. Use a brush-tip marker to make thicker lines in certain areas. After the basic house shapes are created, decorate the houses with lines, circles, and dots.

To create a city view, elongate all the bases to look like skyscrapers. Make the windows repetitive along the facades, and emphasize the height with finials and a flag.

DREAM CATCHER #2

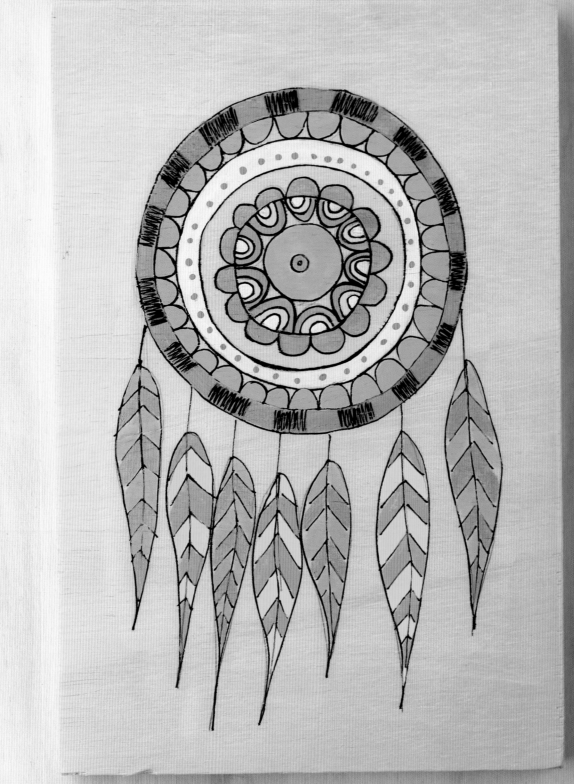

DOODLE PROMPT: Create a dream catcher by doodling circles and then filling them in with details. You can doodle on paper, but try wood instead for a completely different effect.

what you'll need

- Light colored piece of scrap wood
- Black extra-fine-point marker
- Small paintbrush
- Acrylic paints in assorted colors
- Jar of water

instructions

1 Use a black extra-fine-point marker to draw a small circle with a dot in the middle. Draw four more circles around the first circle so that it looks like a stack of five circles. Draw inward-facing scallops in the second space, with the tips of the scallops touching the second circle. Draw outward facing scallops in the third space. Ⓐ

2 Add more details with dots, lines, and shapes in all the areas made by the circles. Ⓑ

3 Draw another circle around the entire piece, and then seven short vertical lines toward the bottom of the circle. Ⓒ

4 Draw feathers that extend from the lines. Fill in more detail in the area created by the outermost circle. Ⓓ

5 Use a small paintbrush to add color to the dream catcher with acrylic paints. Rinse the brush in between colors.

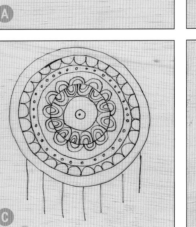
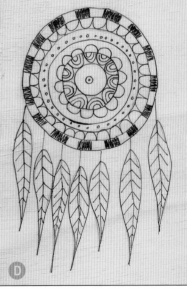

tip

For a fun variation, doodle on a brown paper bag. When finished, add accents with a white gel pen.

PRETTY PAISLEY

DOODLE PROMPT: A paisley shape is actually a curvy teardrop. Start with three layers of teardrops and you'll have several ways to make your paisley come to life.

try it

Use a black extra-fine-point marker to make a curvy teardrop shape. Outline this shape twice to make three teardrops. Doodle loose lines within the three spaces: use angular lines in the outer layer, scallops in the middle layer, and staggered scallops and curvy lines in the center area. Doodle details within these lines in the center and middle layer. Fill in part of the negative space in the outer layer. Add a finishing touch with loose scallops on the outer edge and three leaves at the point.

BLOOM

DOODLE PROMPT: Start with a loose frame, then add minimal touches of doodle and a single word for a sweet and simple finished piece.

try it

Use a black extra-fine-point marker to make a loose rectangular box around the edge of a piece of paper or card. Trace a second box inside or outside the first box to complete the loosely doodled frame. Add small circles or other doodles inside the frame, as you like. In the interior space, add scallops, lines, dots, and shapes, but don't fill the entire space. Keep things deliberately clean and minimal. Add a hand-written word, then use colored markers to fill in the frame and add touches of color on parts of the doodle.

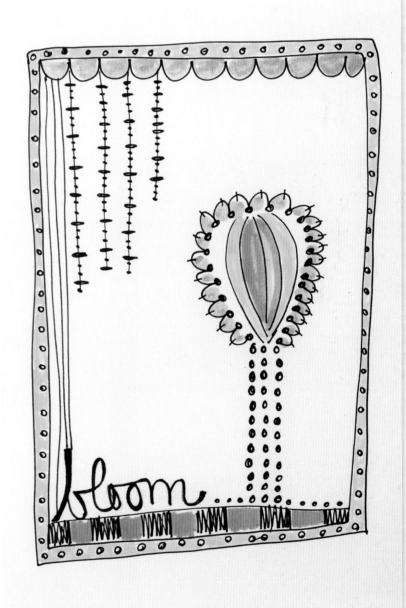

CHARACTERS
With Personality

DOODLE PROMPT: This basic formula can help you create characters of all shapes and sizes. Start with the eyes, and work all the way down to the toes. Just a little practice is all you need to create characters that exude your own artistic flair.

what you'll need

- White paper (anything you have on hand)
- Black fine-point marker

instructions

1 Draw a pair of almond shapes for eyes, and draw lines across them to make eyelids.
2 Make small U-shapes for the pupils and fill them. Make larger U-shapes outside the pupils to complete the inner eyes.
3 For eyelashes, make wedges above the eyes and fill them in.
4 Make a curved eyebrow above one of the eyes that extends down to a point for the nose. Make a second stand-alone eyebrow.
5 For the lips, make a tiny M-shape, then a line below, then a tiny U-shape below that.
6 Draw the face so that the cheeks are close to the outer eyes.
7 Add something to the top of the head, such as horns, hair, a crown, a cake, or a pointy hat.

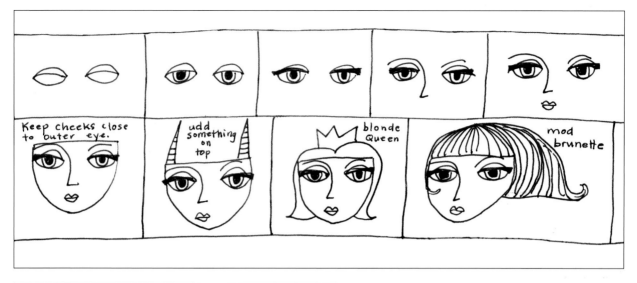

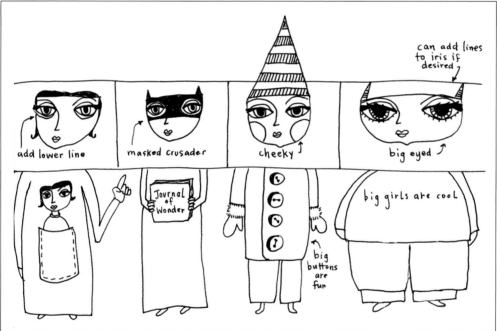

tips

- Leave the characters black and white or add splashes of color with markers, watercolors, or colored pencils.
- Experiment with exaggerating different features. For example, exaggerate the wedges over the eyes and make them super angular; or make the hair gnarly and wavy; or make the body either extremely big or extremely small in proportion to the head. The more you insert your unique point of view and your unique flair into these characters, the more personality they will exude.

8 For the neck, draw two slightly curved parallel lines extending from the cheek.

9 Draw a chunky triangular shape for the body, and add lines to make arms and hands.

10 Add small feet.

11 Have fun doodling in details, such as eyelashes, masks, big round cheeks, a pocket with a doll in it, hands holding a journal, or chunky buttons on a coat.

About the CONTRIBUTORS

Hanna Andersson, also known as iHanna, is a Swedish artist, journalist, and self-proclaimed notebook junkie who enjoys blogging about her creative adventures. To learn more about Hanna, visit www.ihanna.nu.

Julie Armbruster is a New Jersey native currently residing in Asheville, North Carolina. Her mixed media paintings have been displayed in galleries throughout the East Coast and as far as Venice, Italy. Visit www.juliearbruster.net.

Flora Chang is a life-long doodler, currently residing in the Midwest. A full-time designer and illustrator, she divides her time between a job designing products for a greeting card company, maintaining her Etsy shop, and searching for treasures at flea markets. To learn more about Flora, visit www.happydoodleland.com.

Gemma Correll is a freelance illustrator from Norwich, England, where she lives with her two trusty pugs. Known for her cleverly styled typography, comics, and illustrations, Gemma's artwork has been featured in many publications and exhibitions across the globe. To learn more, visit www.gemmacorrell.com.

Cori Dantini, of Pullman, Washington, can most often be found in her studio, covered in a mosaic of ink stains, glue dabs, and bits of paper. A full-time illustrator, mother, and wife, Cori's designs and illustrations have graced canvasses, notecards, and fabric. To learn more about Cori, visit www.coridantinimakes.blogspot.com.

Corinne Dean lives and creates in Chicago, Illinois. Drawing since she could hold a crayon, she has since earned a BFA from the Art Academy of Cincinnati and now spends her time painting, illustrating, and creating charming miniatures for dollhouses. To learn more, visit www.corinnedean.com.

Pamela Keravuori is a painter, illustrator, and teacher living in Virginia. Her studies, as well as her husband's military career, have taken her all over the world, providing opportunities to display her abstract paintings in both American and German galleries. To learn more, visit www.pamelajanes.blogspot.com.

Stephanie Kubo is a freelance illustrator and tea aficionado living in Oakland, California. A graduate of California College of the Arts, Stephanie has an eye for creating colorful, abstract patterns, intricate lettering styles, and linocuts. To learn more, visit www.stephaniekubo.com.

Mafalda Laezza is an Italian artist who is passionate about illustration. She often works with unique materials, creating hand-painted, eco-friendly goods to sell in her Etsy shop. She also enjoys browsing flea markets and shooting with her Polaroid and toy cameras. To learn more about Mafalda, visit www.pinkraindesign.blogspot.com.

Teresa McFayden is a mixed-media artist with an independent streak. Her lifelong passion for teaching has led her to conduct more than 25 online art courses over the past 5 years. Teresa lives in Omaha, Nebraska, with her husband, three children, and beloved yorkie, Lilly. To learn more about Teresa, visit www.teresamcfayden.com.

Dinara Mirtalipova graduated with a degree in Computer Science before realizing her true passion was for drawing and doodling. She now illustrates greeting cards and children's books. Originally from Uzbekistan, she now lives in Cleveland, Ohio, with her family and cat, Matilda. To learn more about Dinara, visit www.mirdinara.com.

Jessie Oleson Moore, known to many as CakeSpy, is an avid blogger and professional seeker of sweetness. As a freelance writer and illustrator,

Jessie has authored two cookbooks and is a regular contributor to *Taste of Home* magazine. She lives in Philadelphia with her pug, Porkchop. To learn more, visit www.cakespy.com.

Teesha Moore is a mixed-media artist, journaler, and the creative force behind annual gatherings such as Artfest, Fiberfest, and Journalfest. She lives in Issaquah, Washington. Visit www.teeshamoore.com.

Aimee Ray is an indie business owner with a passion for crafting, nature, and sci-fi. She is the author of two books on creative embroidery: *Doodle Stitching* (Lark, 2007; 2010). A Midwestern Illinois girl at heart, Aimee currently resides in Arkansas with her husband, Josh, and their two dogs. To learn more about her, visit www.dreamfollow.com.

Cynthia Shaffer is a mixed media artist, quilter, and creative sewer. She is the author of *Stash Happy Patchwork* (Lark, 2011) and *Stash Happy Appliqué* (Lark, 2012). Cynthia lives in Orange, California. To learn more, visit www.cynthiashaffer.com.

Dawn DeVries Sokol is an author, lettering illustrator, book designer, and avid doodler. When she's not inspiring artists at her doodling retreats and online workshops, she is often busy creating in her home studio alongside Lucy, her black lab. To learn more, visit www.dawndsokol.squarespace.com.

Carla Sonheim is a painter, illustrator, published author, and creativity workshop instructor who encourages artists to celebrate the spontaneous, playful side of creativity. She lives in Seattle, Washington, with her photographer husband and game-playing teenager. To learn more about Carla, visit www.carlasonheim.com.

Jennifer Taylor is a California State University graduate who works as an editor for a publishing company. Her passion is painting and she recently displayed her colorful canvases at a local art show. Jennifer also enjoys photography and blogging about her creative journey. To learn more about her, visit www.jenn-taylor.blogspot.com.

editor: **beth sweet**
art director: **kristi pfeffer**
graphic designer: **raquel joya**
photographer: **cynthia shaffer**
cover designer: **kristi pfeffer**
copyeditors: **nancy d. wood, amanda crabtree weston**
assistant editors: **kerri winterstein, monica mouet, jennifer taylor, jana holstein**

About the AUTHOR

Jenny Doh is head of *www.crescendoh.com* and lover of art. She has authored and packaged numerous books including *Creative Lettering, Stamp It!, Journal It!, We Make Dolls!, Hand in Hand,* and *Signature Styles.* She lives in Santa Ana, California, and loves to create, stay fit, and play music.

INDEX